WELLINGTON

THROUGH TIME

Revised Edition

Allan Frost

AMBERLEY

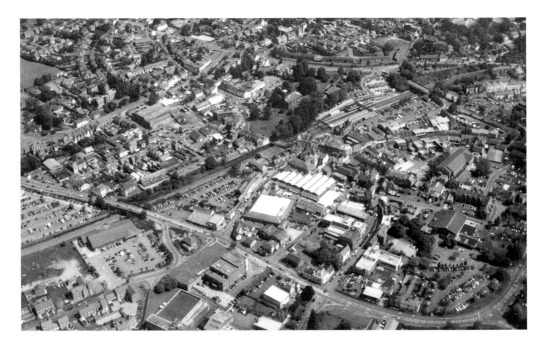

Aerial view of Wellington, looking north, June 2006. The ring road, created during the 1970s, provides a noose around the medieval centre of the town, which is characterised by narrow streets. Over the years, a number of old streets and historic buildings have disappeared in the name of progress.

Dedicated to the memory of my parents, Mary and Leslie Frost,
both of whom were born, bred and buried in Wellington.

First published 2009
This edition published 2015

Amberley Publishing
The Hill, Stroud
Gloucestershire, GL5 4EP

www.amberley-books.com

British Library Cataloguing in Publication Data.
A catalogue record for this book is available from the British Library.

ISBN 978 1 4456 5204 7 (print)
ISBN 978 1 4456 5205 4 (ebook)

Typesetting and Origination by Amberley Publishing.
Printed in Great Britain.

Introduction

Wellington, in Shropshire, began life as an Anglo-Saxon farmstead, sometime during the seventh century. By the time of the Domesday survey in 1086, it also had a few cottages and a Saxon church complete with a priest. Churches tended to attract other settlers as they provided a focal point for scattered communities to get together. A new parish church was erected, probably in the twelfth century, to replace the earlier Saxon church. The scene was set for expansion into a village.

By the Middle Ages, that village had come to fruition. Attendance at church services led to the first markets held when folk came together and took the opportunity to barter and spend time chatting before returning to the relative solitude of their farmsteads. Wellington was for many centuries, central to a farming district and eventually provided essential services which helped it to expand further.

Indeed, the existence of an established market led Giles of Erdington, then lord of the manor, to acquire the town's first Market Charter in 1244. This charter was little more than a tax-gathering ploy, entitling the lord and his heirs to receive a toll on every animal brought into the town for sale at the market. As time passed, the right to collect these tolls was transferred to the Wellington Markets Company; they were phased out after 1954 when the company sold the town's Smithfield (which it had built in 1868) to livestock auctioneers Barbers.

Some expansion to the centre of Wellington was planned between the 1244 charter and the middle of the fourteenth century. New streets were laid out to allow the erection of buildings in a contained way: New Street itself, Cottage Row (later Butcher Row, now Market Street), Walker Street and New Hall Road (later renamed Foundry Lane, the site of which is now occupied by car parks). The name 'New Hall Road' implies someone with wealth – possibly the lord of the manor – intended to erect a new dwelling for himself; it never materialised.

We do not know the reason why, although we can make an educated guess. The arrival of the Black Death in the mid-fourteenth century had a devastating effect on the population. Wellington lost two priests at All Saints parish church within a few years and it's probable that many villagers died with them. The end result was a diminished population and more property than was needed.

Development in the centre of Wellington was virtually frozen for several centuries. Nevertheless, the existing framework saw the arrival of new businesses, like bell making, although the precise location of the foundry eludes us (there is an assumption it was in the area occupied by the Charlton Arms Hotel). Many Shropshire churches

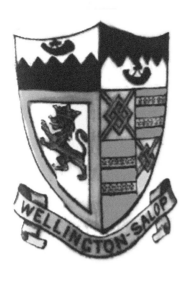

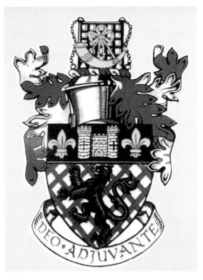

The unofficial town crest was created for visitor souvenirs and guidebooks from the 1890s until 1951 when the present crest (right) was authorised by the College of Arms. The motto *Deo Adjuvante* means 'With God's Help' or 'God Willing'.

hang Wellington bells. Other industries appearing at this time tended towards serving the farming community, while traditional trades (tanning hides, processing fleeces and producing ale, etc.) continued.

The eighteenth century witnessed an upturn in Wellington's economic fortunes. It found itself in an ideal position when mining and iron exploitation, tangible evidence that the 'Industrial Revolution' had arrived in the east Shropshire coalfield, expanded rapidly. New villages appeared and older ones grew, and Wellington provided everything its neighbours needed: ropes, candles, baskets, cartwheels, blacksmiths, carriages, bespoke tailors, drapery stores, food and drink suppliers and offices for surveyors, solicitors, accountants and, eventually, banks. And leisure activities: being so close to the Holyhead Road enabled comparatively easy travel for itinerant entertainers as well as folk wishing to climb the hallowed slopes of The Wrekin Hill, whose fame was becoming world-wide. In a relatively short space of time, the appearance of Wellington changed from that of a large village into a small town.

Prosperity continued unabated for nigh on 200 years. The arrival of railway services in 1849 gave added impetus. Movement of materials and finished goods encouraged new industries which exploited the existence of a varied hinterland where farming was inextricably interspersed between the coalfield and its associated heavy industrial concerns. Yet, despite this thriving economy, the town didn't expand overmuch; both business and housing tended to make use of existing roads and streets, which eventually became overcrowded and cramped. Even as late as 1900, the street network still resembled that of 600 years earlier.

The first seventy or so years of the twentieth century, in spite of its wars and economic depressions, witnessed a continuation of a thriving economy characterised by innumerable family-run shops and

Opposite page: The first aerial photograph of Wellington, taken around 1923, probably by ex-First World War Royal Flying Corps pilot Francis Willis. Tan Bank runs from centre bottom northwards. Market Hall is centre left, while All Saints parish church is top right. New Street curves from the middle to the right.

relatively small-scale industry. Wellington was still the focal point for all things social, economic, and political in east Shropshire.

Then the bubble burst. In 1968, the Government decided that the proposed Dawley New Town boundary would be extended to incorporate other townships in the area, Wellington included. The resulting conurbation was renamed Telford. In 1974, local government reorganisation resulted in Wellington losing control of its destiny and, it is fair to say, has since been subject to an unprecedented degree of investment neglect by the controlling Telford and Wrekin council.

Inconsistent and unsympathetic planning has led to the centre of Wellington, like so many other towns in the country, looking like a planner's dream where concrete, UPVC, flat roofs, gaudy oversized signs and a surfeit of 'street furniture' have spoiled the understated yet respectfully restrained streetscape of – was it only fifty years ago? Things are apparently changing; after 40 years, another revision to Borough policies indicates that considerable sums have been promised (again) in a much needed attempt to kick start the economies of Wellington and other similarly affected townships within the conurbation. However, the council's (apparently unwritten) policy of attracting visitors to Telford solely to the privately owned Telford Shopping Centre and the (effectively) privately owned Ironbridge Gorge Museums, and not to its traditional historic settlements, remains an uncomfortable anomaly – as does the borough council's lack of concern (and, indeed, seemingly active encouragement) with regards to the destruction of aspects of the town's heritage.

Heritage buildings and streetscapes are precious commodities and, unlike businesses, cannot be replaced. Let's hope that things improve for the benefit of Wellington and other long-established towns and villages comprising the Telford area.

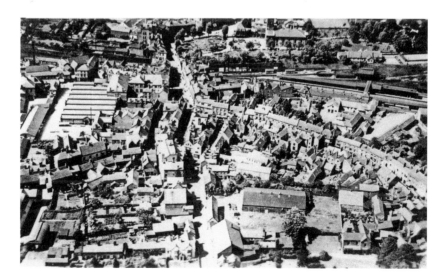

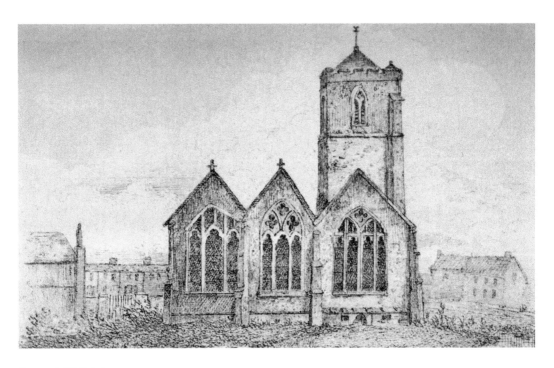

Around All Saints

The medieval parish church of All Saints (above, in an etching by William Pearson, 1787) was severely damaged during the English Civil War when Parliamentary troops occupied it – and used its statues and windows for target practice. It was allowed to decay even further before demolition in 1789. The present church, designed in a rather uncompromising style by George Steuart, was erected in 1790. The photograph below was taken around 1909.

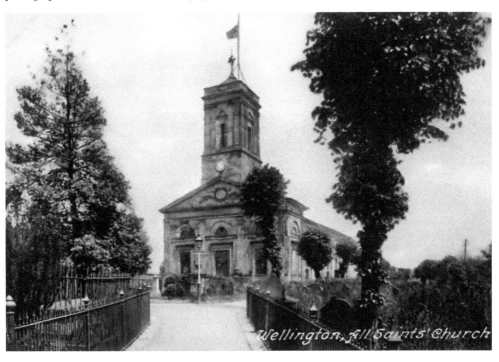

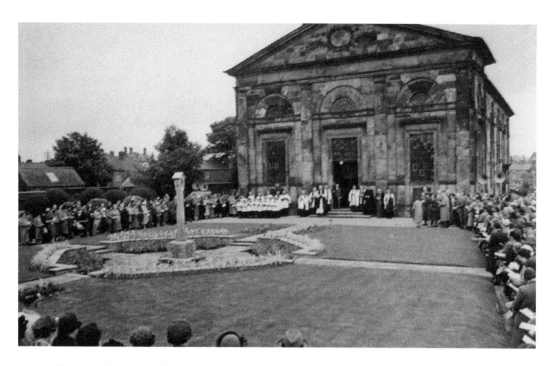

All Saints Churchyard West

Having once served a much larger parish than it does today, the churchyard at All Saints eventually became overstocked with corpses and presented a hazard to health, leading to the creation of a municipal cemetery off Linden Avenue in 1875. The churchyard ground was levelled in 1952 to create a Garden of Rest to celebrate the forthcoming coronation of Elizabeth II. The photograph above shows the Service of Dedication. In medieval times, churchyards were the meeting place for many secular activities, an aspect revived in recent years as the focal point for Midsummer Fayre festivities.

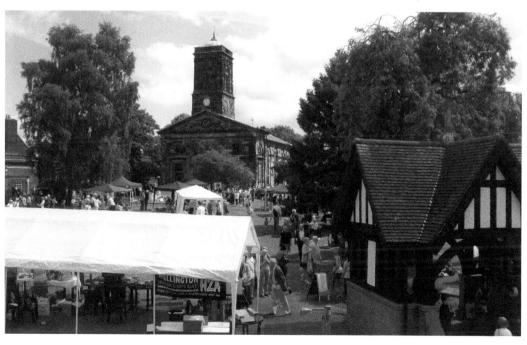

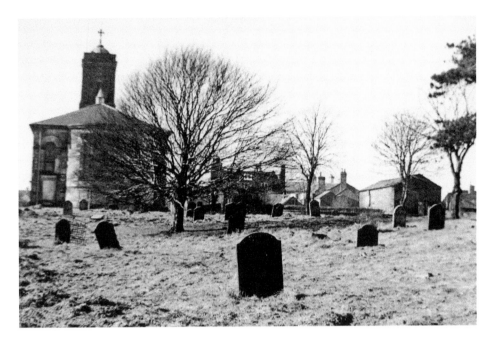

All Saints Churchyard East

Before All Saints churchyard was levelled, whereas the western section was crammed with railinged graves and family vaults, the extensive eastern end (above), with only a few scattered headstones and monuments, was desolate and unkempt. It contained the grave of four of the author's great-great-grandfather's children who died in an explosion in 1839. Their headstone is one of the few to have survived the transformation into a Garden of Rest (it is now propped up against a perimeter wall) and is the main reason he became interested in local history. Mature trees now obscure the view from early summer to late autumn.

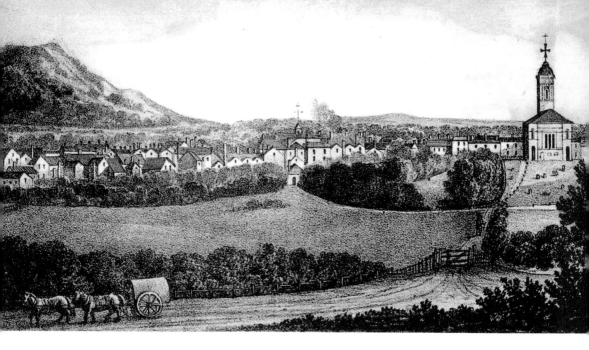

King Street

The image above shows the earliest known landscape illustration of Wellington. It was created around 1824 when the picture was first published in *T. Gregory's Shropshire Gazetteer*. The tall building with a weatheryane in the center of the lithograph is believed to belong to Robert Houlston's famous printing works. New Street runs off to the left with the Wrekin Hill in the background. King Street, in the foreground, was then called Back Lane and acted as an early bypass for travellers not wishing to enter the town's narrow streets. The modern photograph, taken from Constitution Hill (earlier called Belle Vue), shows King Street still acting as a bypass for traffic.

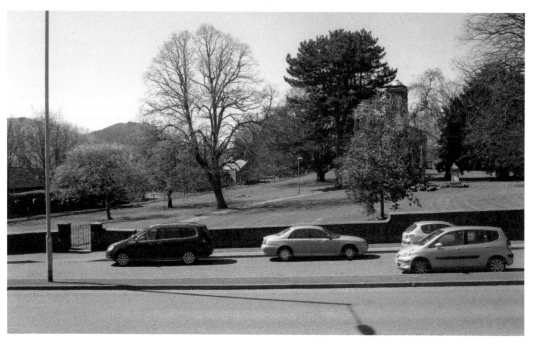

9

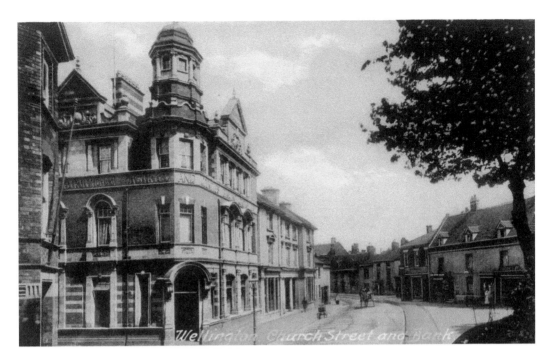

The Green Looking North

The Green, the oldest part of the medieval village, has managed to survive despite being encroached upon over the centuries. This view along Church Street, taken around 1900, shows the triangular patch of The Green on the right and the imposing Birmingham District and Counties Banking Co. premises on the left. Barclays bank eventually acquired the building and demolished it around 1960, replacing it with a more functional concrete-and-glass construction – totally out of keeping with the town's character. A NatWest Bank (originally National Provincial Bank) was built on The Green in 1926.

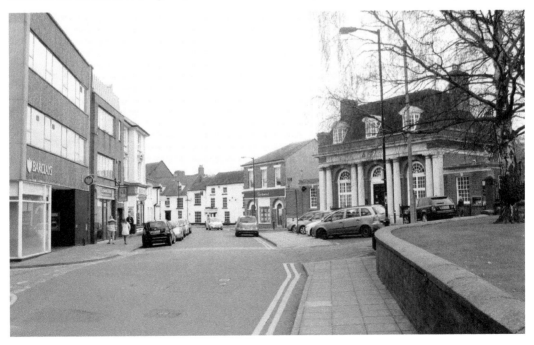

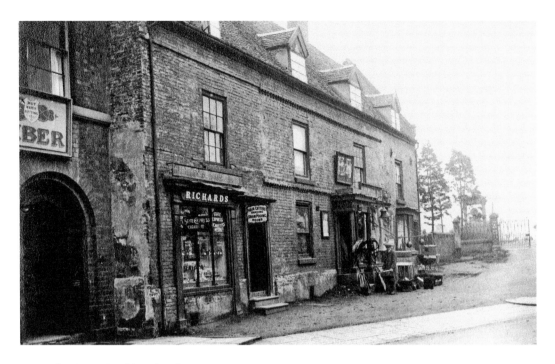

The Green Looking South

This small car park is all that remains of The Green. Whereas it had been allowed to remain largely untouched for a time, Wellington Urban District Council took the view that finding five extra car parking spaces was more important than preserving heritage. Until the present Market Hall opened in 1864, The Green was the site for general markets and (until John Barber opened his original Smithfield in 1855 near the Victoria Street railway bridge) livestock auctions. The iron gates into All Saints churchyard in the early 1920s scene remain in the same location as when they were donated by late Victorian fishmonger and fruiterer John Crump Bowring, after whom the town's recreation park is named.

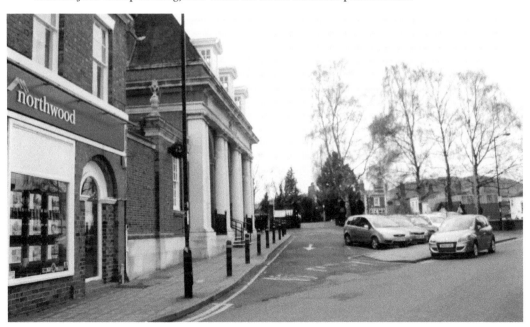

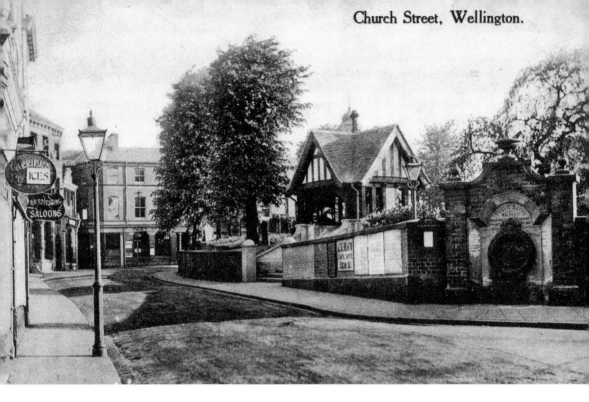

Church Street South

The southern section of Church Street adjoining Market Square, seen here after the timber-framed Lych Gate war memorial was erected in 1922, was called Market Place in the early 1800s, at which time Church Street began at The Green. By the 1830s, Church Street included this portion. The railway bridge, constructed in 1849, is covered with posters. Next to it is the equivalent of a petrol station for vehicles of the time: a horse trough (extreme right) advertising the Public Baths which had opened in 1910.

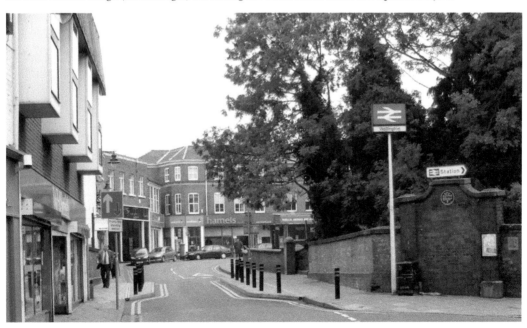

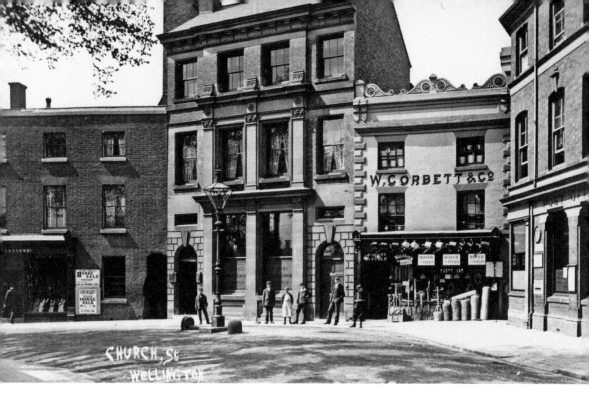

Church Street

The view above shows the left-hand corner of the previous photograph and was taken in 1904. From the left: Brisbourne's gents' outfitters, Auctioneers Hall, Wateridge & Owen, Lloyd's Banking Company Limited, W. Corbett's ironmongery and the post office. The narrow archway between the auctioneers and bank is a lane called Ten Tree Croft, an allusion to a medieval 'tenter croft' where woollen cloth was stretched after washing to prevent shrinkage. Much of the character of these buildings has been lost by gaudy signs and modern 'improvements'.

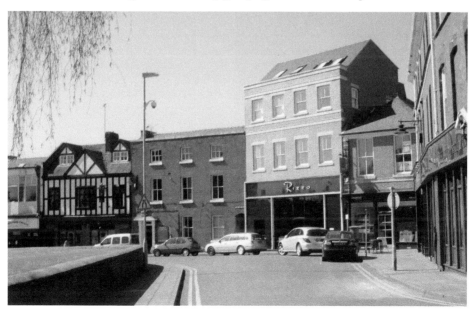

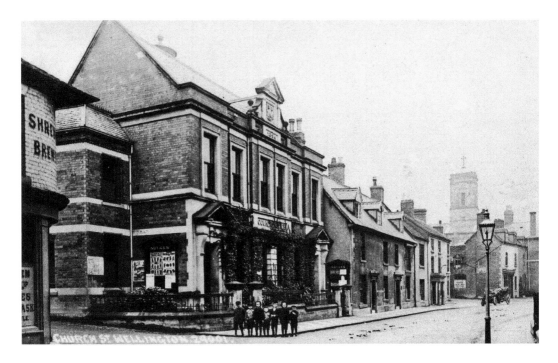

Church Street North

Looking southwards towards All Saints. Shrewsbury and Wem Brewery had a trade outlet and off-licence on the corner of Plough Road (left), the opposite side of which features the former police station and Magistrates Court built in 1896. The Charlton Arms, which opened as a hotel around 1849, with a modern blue sign and columnar portico, became the most highly respected venue for all manner of civic functions until it suffered fire damage in 2006. Now closed, it languishes, desperate for a new lease of life. Children in the earlier 1900s photograph have been replaced by folk on one of the author's town walks in 2009.

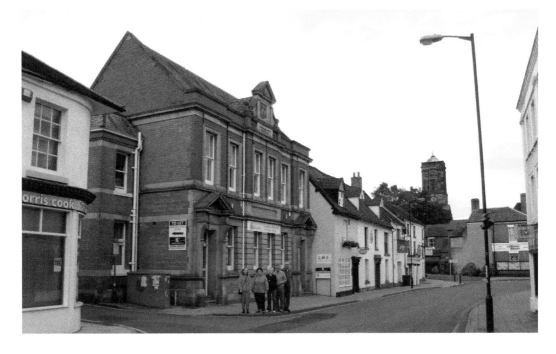

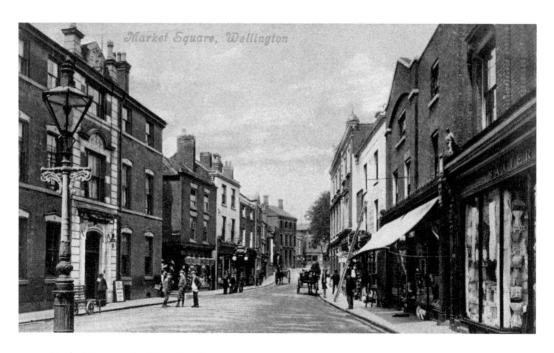

Market Square Looking North

The commercial heart of Wellington, looking north. Sun blinds, which were commonplace fifty years ago, have all but disappeared and shop signs are more garish than they ever were in 1900. The famous Wrekin Hotel was eventually taken over by Stead & Simpsons' shoe shop which has become victim to the current economic situation and has recently become yet another charity shop. However, HSBC bank (scaffolded) is undergoing renovation work to bring it into line with a programme of frontage refurbishment. Victorian and earlier town officials understood the need to keep Market Square open and uncluttered – a fact which has progressively been ignored over subsequent years. The Community Clock, paid for by public subscription to mark the 'New Millennium', is one of few welcome additions.

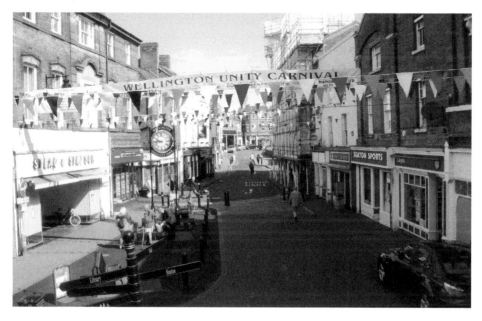

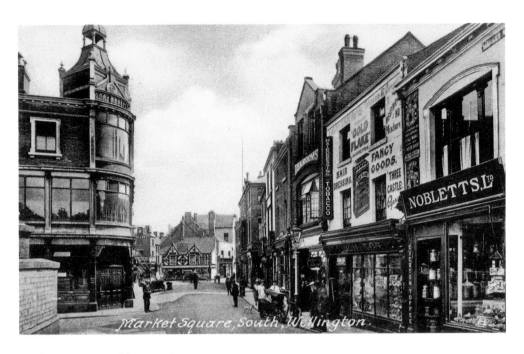

Market Square, South, Wellington

Market Square Looking South

View southwards into Market Square from Church Street. The shop on the extreme right was recently occupied by the Co-operative Funeralcare; until 2014 the premises were a W. H. Smith store, built by Menzies in 1970 (entailing the demolition of three shops, one of which, Nobletts, had previously been the Six Bells public house, an allusion to the six bells of the twelfth-century parish church). The timber-framed Subway building in the distance has survived, as has the HSBC (formerly Midland) bank on the corner into Station Road; wthis building appears to date from 1901 at which time it was the North & South Wales Bank, with a gents' outfitters above.

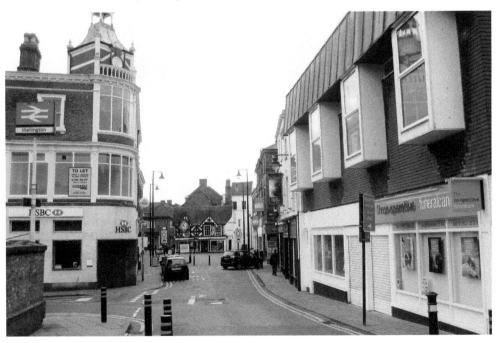

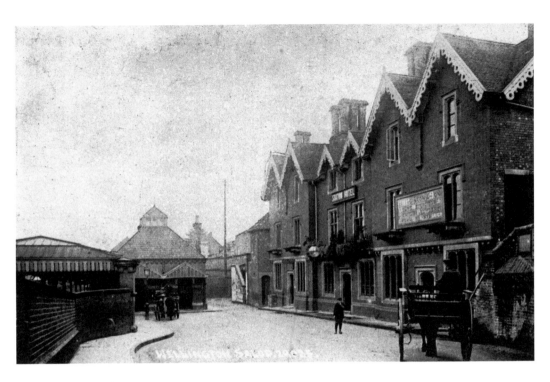

Station Road

Very little has changed in Station Road. Cars have replaced horse-drawn carriages and the outward appearance of Henry Pointon's early 1900s Station Hotel (with a large advertisement for his plumbing and decorating business in Crown Street) remains recognisable, although the smoking ban of 2007 has led to the introduction of outside tables. The railway opened in June 1849 and, because part of All Saints churchyard was encroached upon by the station cutting, a cross was placed on top of the booking office as a mark of respect. Before 1849, a small pool existed near the site. The hotel seems to have been built around 1860 by John Jones (a maltster and farmer who had previously kept the Fox and Hounds in Crown Street) to cater for an increasing number of visitors to the town.

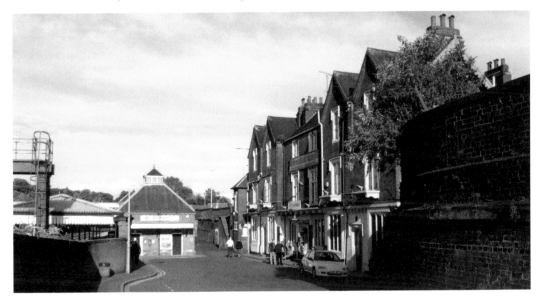

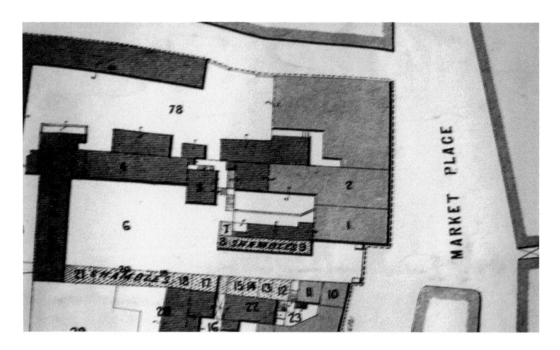

Market Approach

Most towns would give their eye teeth to be able to call a street, with any degree of historical authenticity, The Shambles. That's what Market Approach was called for centuries before the name was arrogantly considered inappropriate for a respectable town. It's the traditional name given to an area where butchers' stalls were located. The plan was drawn by auctioneer John Barber in 1864 and shows the former town hall as well as numbered butchers' stalls. He also prepared a list of who occupied each plot; they all disappeared when the present Market Hall was built soon afterwards. Hill's butchers on the left is a reminder of how this street got its original name. Plot 1 on the plan (now Hammond's Café) was Thomas Webb's grocery store, 2 was Robert Hobson's stationery and book shop (his printing works were at Plot 4).

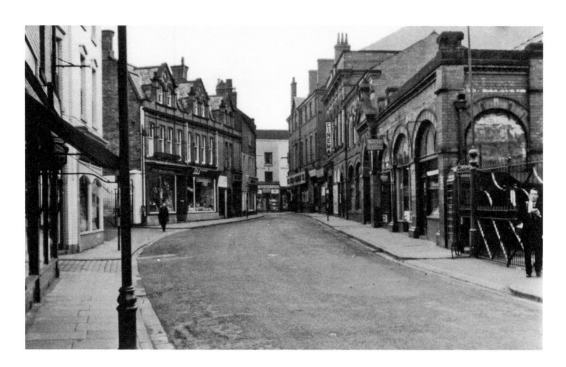

Market Street

Market Street looking east in May 1960 and June 2009. Very little has changed to the structure of the buildings although, inevitably, the appearance of shop frontages has. The original Market Hall gates on the right leading into the 'Outside Market' and the shops on the extreme left have been replaced, and the old-fashioned telephone kiosk by the gates was removed to enable the corner shop to be built. The street was laid out in medieval times and originally named Cottage Row, later Butchers Lane or Row, owing to its close proximity to The Shambles. The narrow exit from Market Square in the distance has caused congestion to traffic for several hundred years; until the late 1930s, vehicles were allowed to move in both directions.

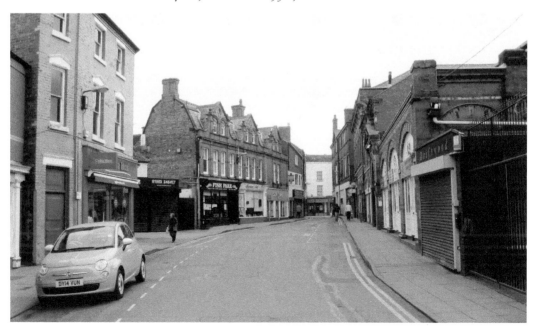

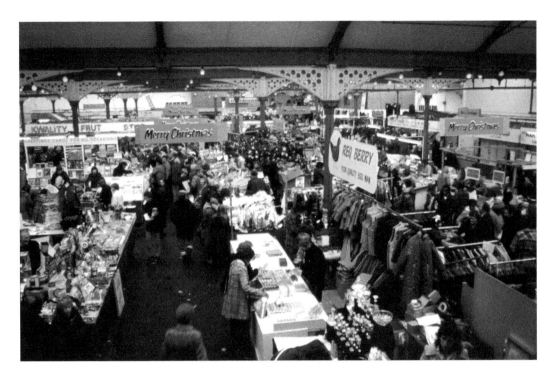

Market Hall

Site of the town's general market for 145 years and, until the 1920s, occasionally used for storing fleeces for auction by Barber & Son. Many of the stalls of the inside market in the 1970s are no longer open, having been replaced by secure shed-like units which can appear claustrophobic. Wellington continues to survive one economic downturn after another largely because the market attracts many regular shoppers looking for bargains and fresh produce.

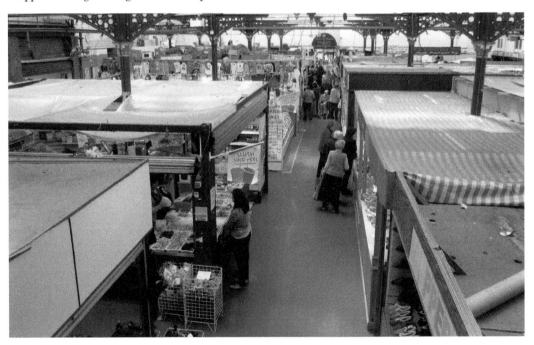

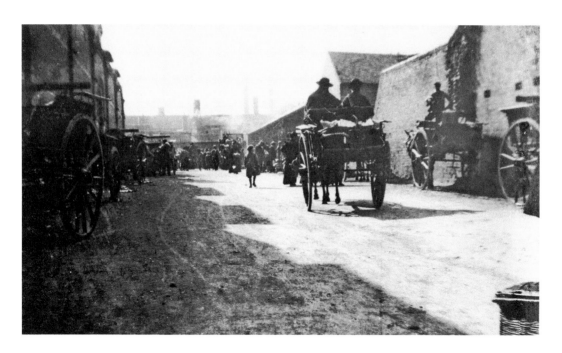

Outside Market

The 'Outside Market' was, from the outset of its 1860s creation, known as the 'Potato Market'. Initially a large open space, it eventually had a covered open-sided 'Potato Shed' at the far end which was subsequently extended. Sometime after the Great War, stalls backing onto the western wall of Market Hall (on the left) were built with the result that the 'Outside Market' is now crammed with vendors selling all manner of goods. If current Wellington Market Company proposals come to fruition, this area will see another transformation.

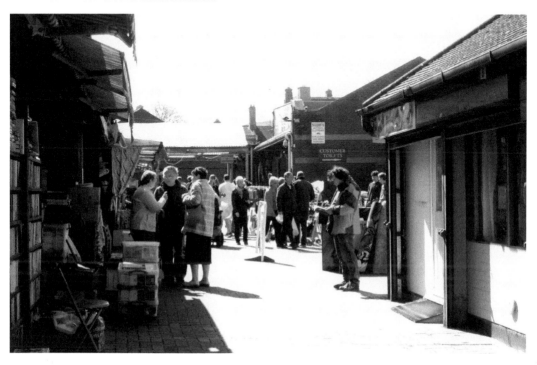

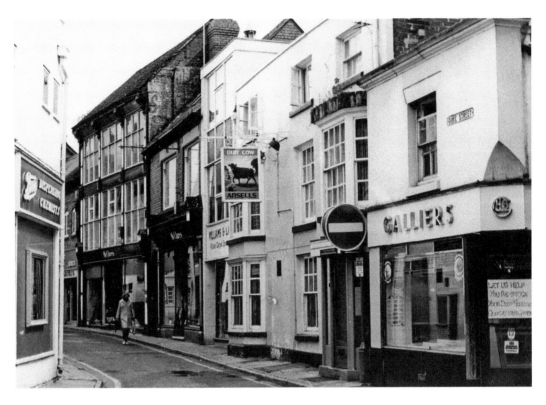

Duke Street Looking South

Originally called Dun Cow Lane after the pub, many of the buildings on the right have replaced much older properties, including McClures' clothing, soft furnishings and fancy goods outlets. There has always been a butcher's shop on the corner into Market Approach, although Morgan's (Gallier's in 1960) is seeking new premises as their lease is due for renewal.

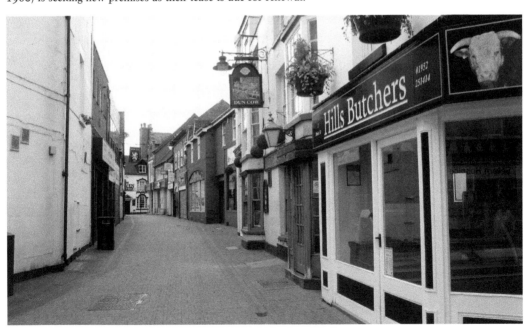

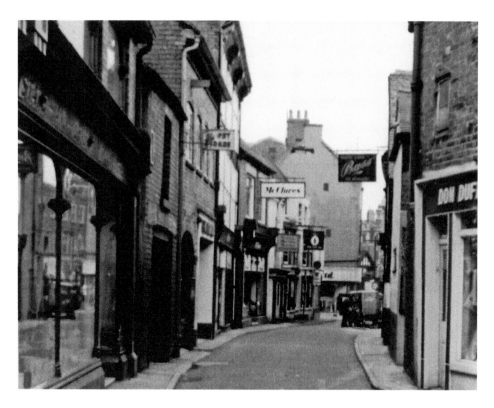

Duke Street Looking North

Opposite view down Duke Street, looking northward. In May 1960, Walter Davies had an ironmonger's and hardware store on the left which opened in the early years of the twentieth century. It closed around 1970, to be reoccupied by the Halifax Building Society, now HBOS.

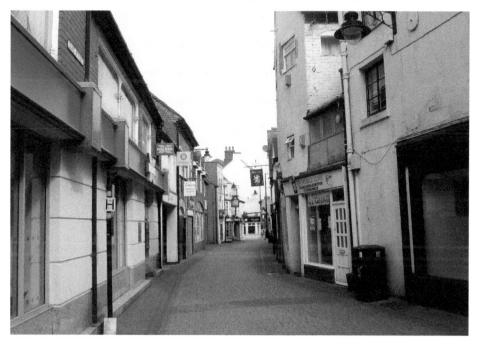

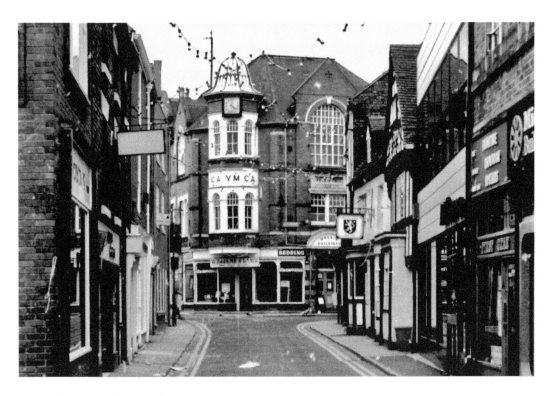

Crown Street Looking South

Named after the Crown Inn (left, now occupied by *Wellington News* offices), this street has managed to preserve its rows of small properties, some of which have taken advantage of a current scheme to refurbish their frontages to resemble Victorian-style shops. The timber-framed White Lion public house (centre right) is one of the oldest buildings in the town to retain much of its ancient appearance.

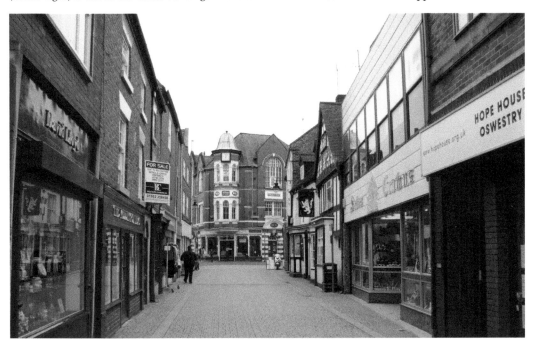

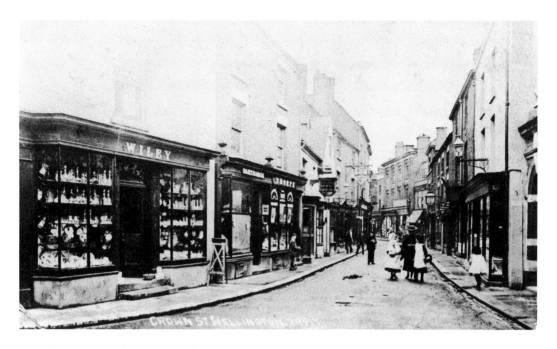

Crown Street Looking North

Crown Street, looking north, leading from Walker Street into Market Square, the entrance to which lies in the far distance. Repaving work took place in 2007 and replaced red-brick paviors which had not been maintained since they were laid in the mid-1980s. Contrast this with the dirt street of over 100 years ago, where horse manure awaits collection by an avid Edwardian rose grower! Although several shops (like Wiley's china and glassware store, latterly Frederico's and currently Palace of Beauty) await new occupants, the street retains much of its individuality.

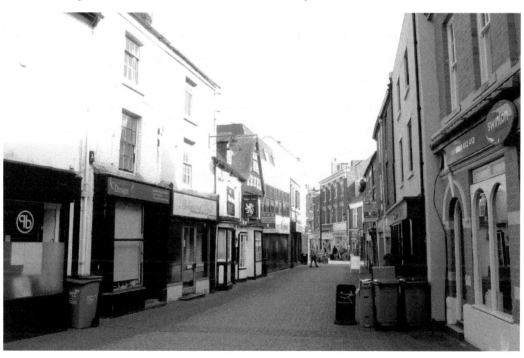

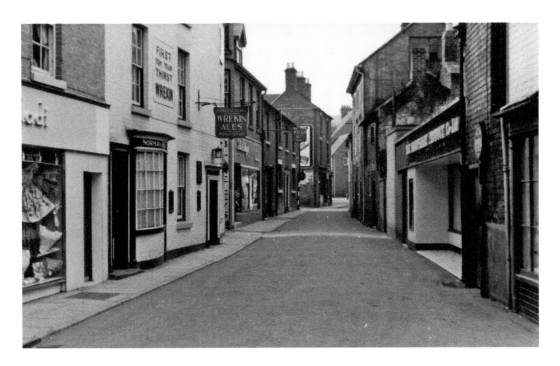

Bell Street

Formerly known as Pump Street and later Swine Market because of the pig auctions that took place here, Bell Street (like Dun Cow Lane) was renamed to satisfy a general desire to clean up Wellington's image by town improvement commissioners during the latter half of the nineteenth century. The current name is derived from the Bell Inn, which was located roughly where The Corner Research and Holland & Barrett premises are today. The Shropshire Produce premises of 1960 are now awaiting new tenants and are located where the rear stables and outbuildings for the former Crown Inn in Crown Street. Miladi's women's fashion and underwear shop has been a ladies' hairdressers for many years and the Wrekin Brewery's Rose and Crown pub has been split into two shop-cum-offices.

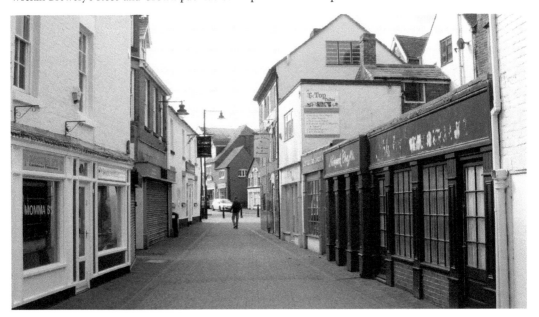

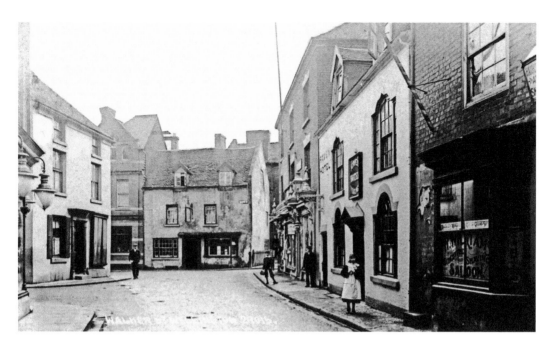

Walker Street East

Walker Street is one of Wellington's medieval streets, so called because it was the site for treading (or 'walking') fleeces as part of a woollen goods manufacturing process. The Fox and Hounds public house in the centre (at the end of Crown Street) was rebuilt in 1907 and given a red-brick appearance, while the Raven, another old hostelry, has been renamed Rasputins for some unfathomable reason. W. Williams's gents' haircutting and shaving saloon on the right is now part of Oriental Chef Chinese Takeaway.

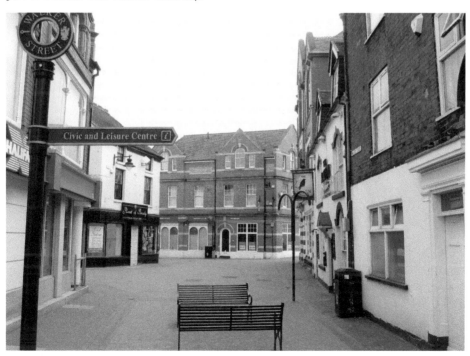

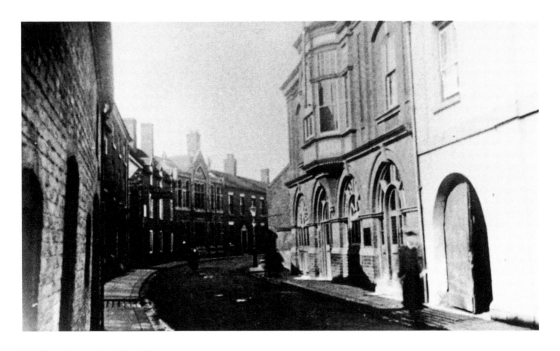

Walker Street Looking West

Walker Street looking west with the library in the middle distance (it was replaced by a new library in 2012). The white building on the left of the modern photograph once had an archway leading into the Fold Yard of the Sun Inn, which became Edgbaston House in the 1890s and has been converted into sheltered apartments. The old, arched red building on the right, which incorporates one of the entrances to the market, was originally the office of Wellington Urban District Council and the place where the town's fire engine was stored for many years after leaving the yard behind the Sun Inn.

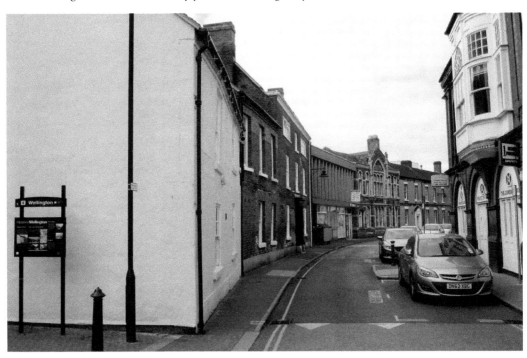

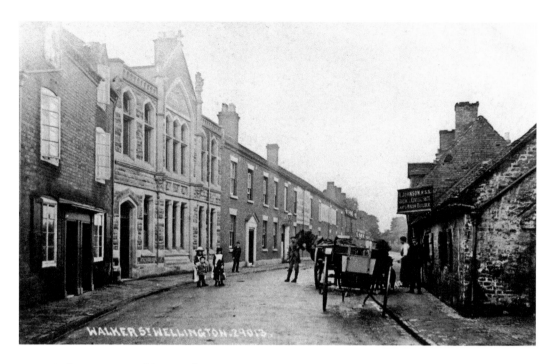

Walker Street Looking Further West

Further along Walker Street, Wellington Library has expanded to the left of its impressive 1902 Edwardian frontage, where a 1960s glass-and-concrete extension with an archway leads into Larkin Way. The Way was named after poet Philip Larkin, town librarian from 1943 to 1946, who officially opened the extension (which replaced several old dwellings) in 1962. The library also expanded to the right, into the town's former Union Workhouse, which was taken over by the Union Brewery after a new workhouse opened on Holyhead Road in 1875. R. Johnson's Shoeing and General Smithy and Cart and Wagon building premises are now occupied by the Royal Mail Sorting Office which also housed, until recent years, the town's main post office.

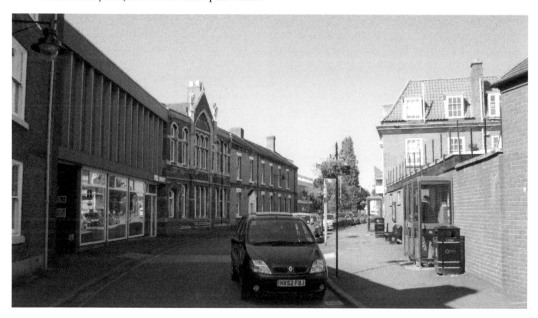

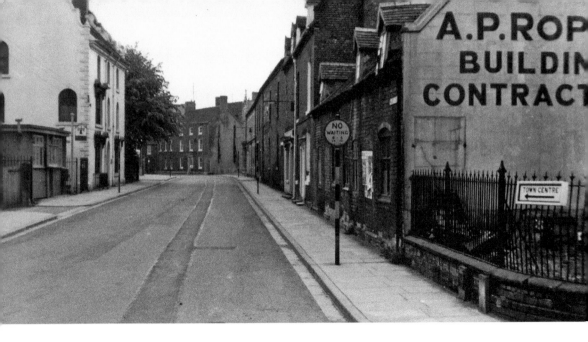

Walker Street West

Looking eastwards from the western end of Walker Street, Edgbaston House can be seen in the far distance. The most noticeable changes along the right-hand stretch came about during the mid–1960s when HM Inspector of Taxes built Crown Building, a white-tiled monstrosity (seen on the right), on a site where Alfred Roper's builder's yard and a row of very old cottages and a few shops and offices had previously stood. Following one of several reorganisations of Inland Revenue staff and offices during the 1990s, Crown Building became became CSL Furnishing's low-cost furniture store which ceased trading in 2009. After a brief spell as a Chinese supermarket, the present firm trades as 'Wellington Express Discount & Convenience Store'.

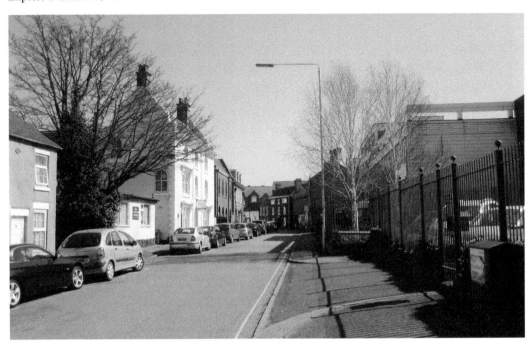

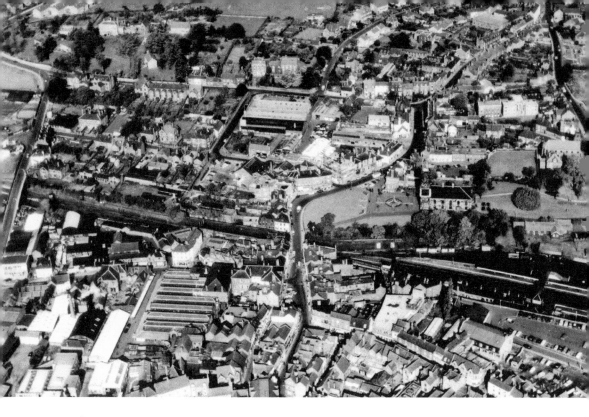

Railway Division

Slightly different north-facing aerial views of Wellington around the railway station, which cuts through the town on an east–west axis. Little appears to have happened to alter the general street layout in this part of the town over the last fifty years, although Vineyard Road, which runs parallel to the railway line, has been extended to join King Street. Note All Saints parish church partially hidden behind trees opposite the main rail booking office, and Church Street wending its way around the western edge of the churchyard.

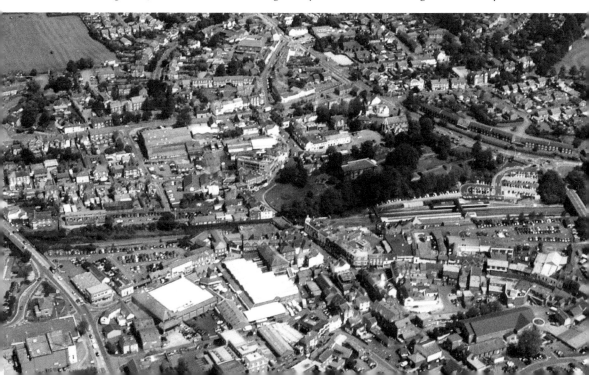

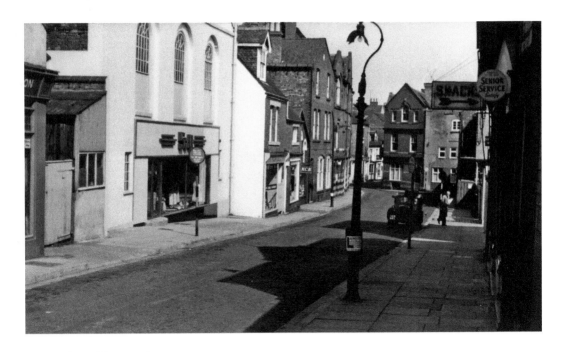

Tan Bank Looking North

Here is another street whose name derives from a medieval occupation: leather and hide tanning. It has also been known as Pool Head Lane, an allusion to there being a pool at its northern end (in front of where the red-brick former Fox and Hounds public house stands in the centre of these views). The large white building on the left began life in 1825 as a Congregational chapel but closed in 1884 because of dwindling congregations. It has since had a variety of commercial and business uses.

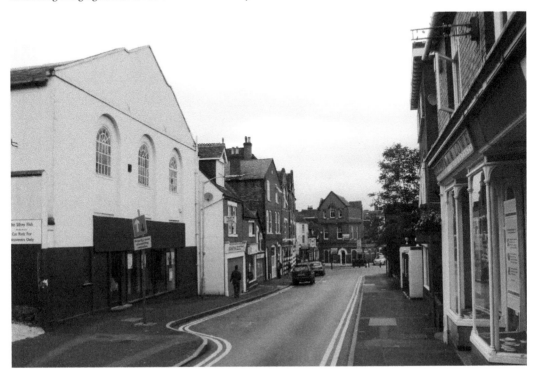

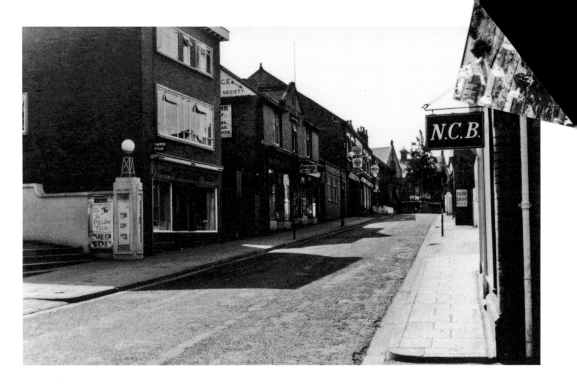

Tan Bank Looking South

Tan Bank, looking south in 1960 and almost fifty years later. To the left, steps to the Grand Theatre, destroyed by fire several years ago, have been superseded by the entrance to Whispers Wine Bar and Pussycats nightclub. At the far end of the street, the former Tan Bank Primitive Methodist chapel and Sunday school buildings now engage different groups of worshippers. Much of the property along Tan Bank has altered very little (apart from many different occupiers), although buildings out of sight on the extreme right have been demolished to clear sites for the present Civic Offices and related car parks.

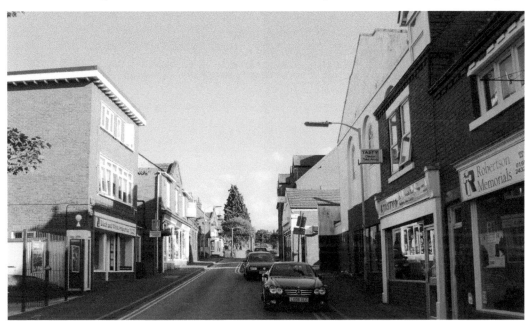

33

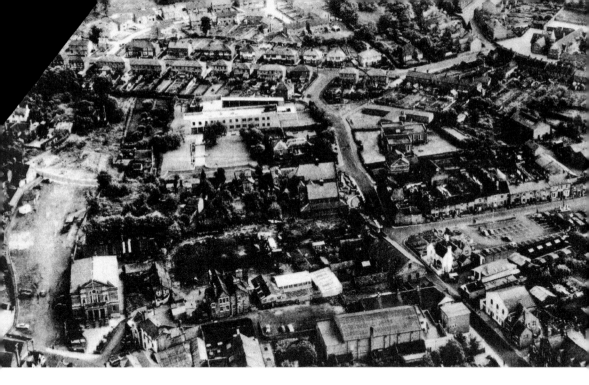

Foundry Lane

Foundry Lane, originally called New Hall Road in late medieval times and renamed in view of at least one brass and iron foundry existing along its length, no longer exists: it was demolished to make way for Wellington Civic Offices in the early 1980s (below, where the remnants of Bernie Pugh's Antiques shop and, on the left, Tan Bank Methodist Sunday School can be seen). Above (1958), a short stretch of the lane runs to the right off Tan Bank, the road running up from bottom right towards the centre. The Wesleyan Methodist chapel in New Street is bottom left, adjacent to a long patch of waste land used as a car park, destined to become part of the ring road.

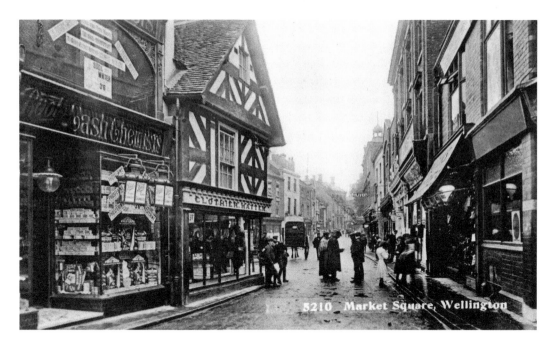

5210 Market Square, Wellington

New Street into Market Square

New Street is the main thoroughfare of Wellington and was first laid out during the thirteenth century. It joins Market Square at its western end via a sharp turn through a narrow entrance, which causes considerable inconvenience to long vehicles and occasional damage to the timber-framed shop, once Walter Davies's gents' outfitter, now a Subway sandwich shop. Boots came to the town towards the end of the nineteenth century and remained in this spot until the 1980s, when it moved further up New Street to its present, larger, premises. In the 1950s, George Mason's on the left of Boots was probably the first grocery store in the town to use baskets for customers to select their own items when shopping rather than ask an assistant to put an order together.

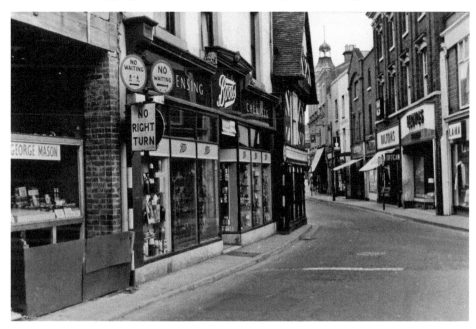

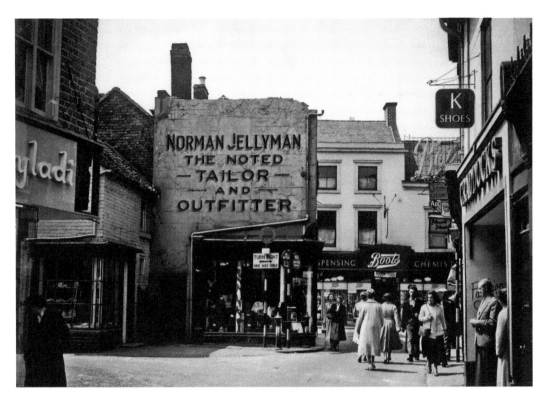

New Street West

Western end of New Street. Until about 1960, Jellyman's (previously Grainger's) outfitters operated from premises which jutted out into the road, causing something of a bottleneck at the right turn into Market Square until demolished to make way for C. D. Jones's children's wear shop (now David Lloyd's jewellers).

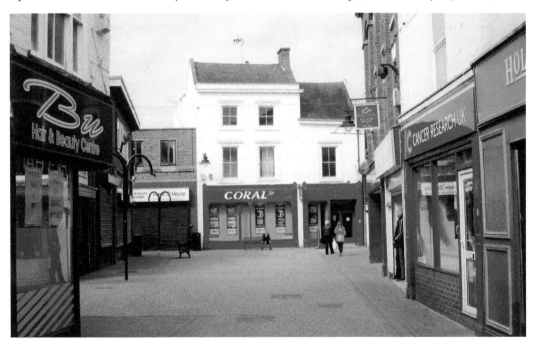

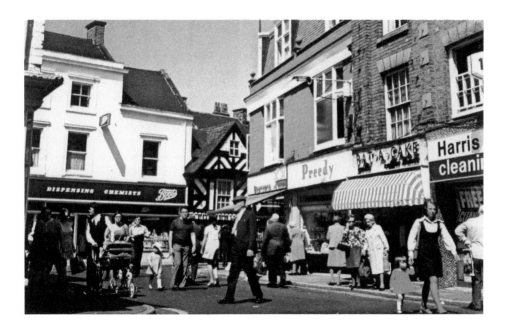

New Street West

These 1960s and 2009 photographs were taken from the entrance into Bell Street. As elsewhere, ground-floor façades have changed to show current occupiers. Pat-a-Cake café was highly popular with pupils from Wellington Boys' Grammar and Girls' High schools. Greggs, formerly Stanton's, bakery was, until 1960, the site of the Lamb Inn, and the lower-roofed part of Boots (now Coral bookmakers) was the Fox and Grapes public house, run by the Shakeshaft family since before 1835 until the 1860s. William Hill bookmakers' unsightly upper windows have been covered because of a few broken panes. The window jutting out on the extreme left belongs to the Sweet Jar, previously Jefferies' bread and cake shop from the 1950s until 2008 (as shown in the previous photograph). Prior to that it had been a butcher's shop.

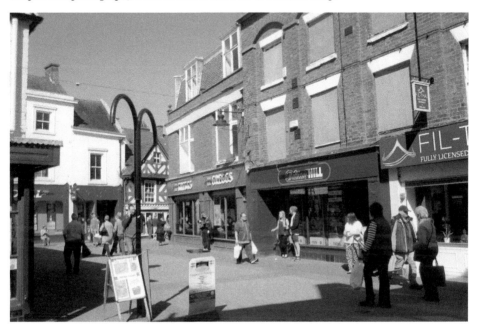

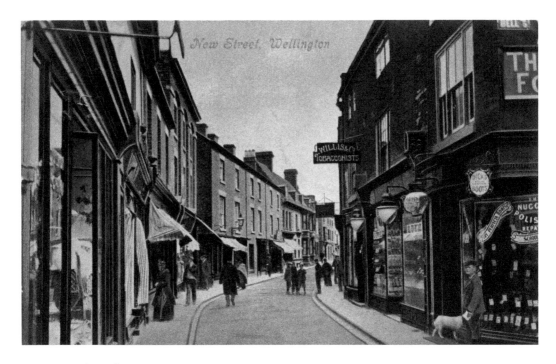

New Street by Bell Street

Views looking eastwards from the corner into Bell Street (right). A lot can happen in 100 years, perhaps most noticeably on the left where several old shops with narrow frontages were demolished in the 1950s to modernise (with concrete and glass) the frontage to Woolworths, which came to the town in the early 1930s and closed in January 2009. The same applies to the site now occupied by Boots. Sadly, unsightly security roller shutters and in-your-face signs dominate the scene, in sharp contrast to functional yet comely sunblinds and discreet signs above and inside shop windows.

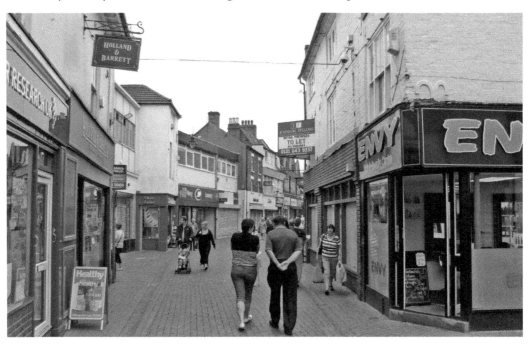

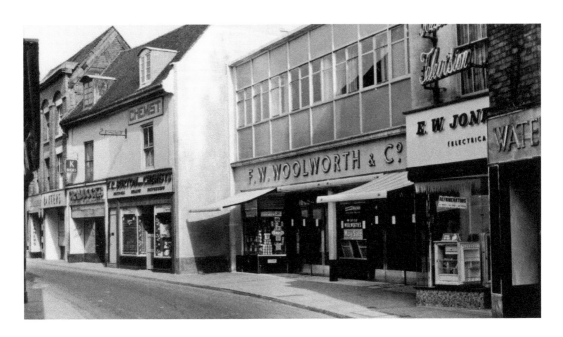

F. W. Woolworth & Co., New Street

A clearer view of lost character is evident in these contrasting photographs from the 1920s and 1960, especially when compared to the two previous images. The profile of shops has been considerably hardened; Woolworths' refurbishment destroyed the subtle cohesion of normal (for Wellington) late medieval with adapted Victorian frontages, a feature relating to the corresponding narrowness of burgage plots. Planners and planning authorities have much to answer for by allowing such incongruous and unsympathetic utilitarian architecture to ruin the streetscape. Even as late as 1960, many shops were still run as family concerns, with the families living above and behind the premises. Heron Frozen Foods began trading in July 2009 in the former Woolworths store.

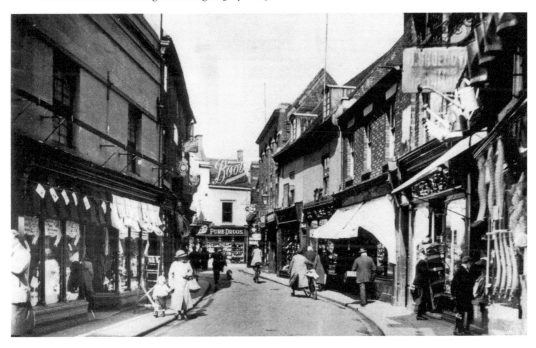

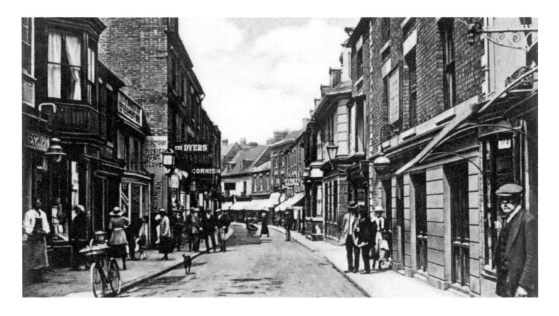

Central New Street Looking West

These photographs promote examples of how architecture from the 1960s and subsequent years can ruin an otherwise pleasing central New Street scene. The number of charity shops within the town centre has reached frightening proportions, to the point where they themselves have voiced concern over too much competition! The building on the extreme left of the 1930s scene had been George York's pub called the George and Dragon – until his plumbing and decorating sideline dominated from around the 1870s onwards – and continued until it was all demolished in a fit of modernisation in the late 1960s. The Wrekin Brewery's Duke of Wellington Hotel (on the right) fell victim to 'progress'; replaced by an unimaginatively designed Fine Fare supermarket in the late 1960s, it has been home to several low-price goods stores before complete refurbishment in 2011 when Wetherspoon's opened it as the William Withering pub, a popular venue for all ages which is blessed with numerous images from the town's past adorning its walls.

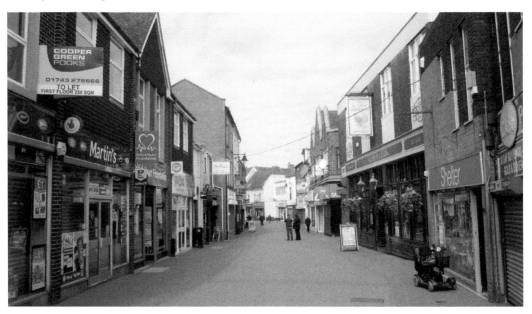

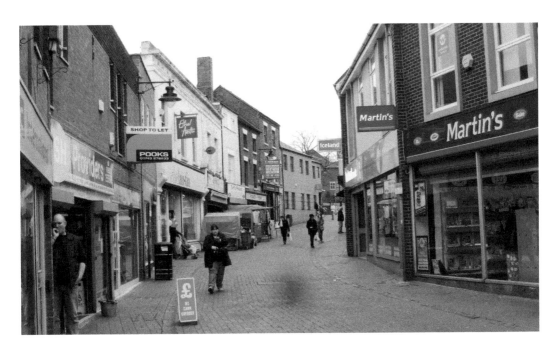

Central New Street Looking East

These are the early 1900s and 2009 views seen by turning round from the previous location. Again, modern buildings have replaced Victorian shops but, here at least, a few have survived. Hayward's tall and narrow rope works, demolished in the 1940s or '50s, dominated the skyline in the far distance; the ring road, completed in the 1970s, now occupies that space. Bourne's Gift Emporium (on the right next to Howes' grocery shop), once renowned for its fine arts, picture framing and Wellington and Wrekin Hill souvenirs, was later home to the Co-operative Wholesale Society before it succumbed to demolition. Iceland frozen foods store occupies the modern premises.

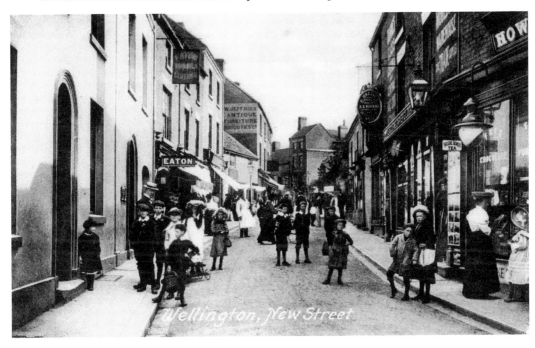

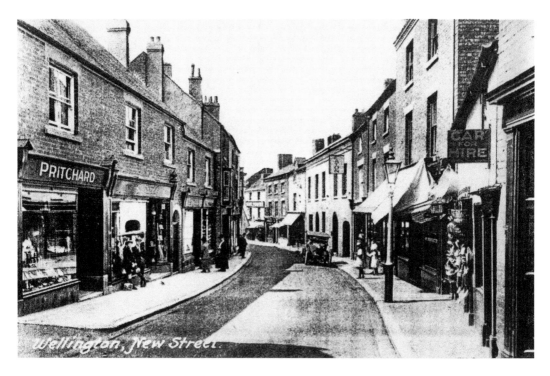

New Street East

Further east along pedestrianised New Street. Most of the old properties have managed to survive but don't appear to be quite so picturesque as they were in the 1930s, when traffic was allowed to travel up and down the main thoroughfare. Whereas the first and higher storeys of buildings tend to be eminently recognisable, ground-floor windows, with their over-shop signs and shutters, don't seem quite so out of place as they are in previous New Street scenes. Despite the existence of a couple of charity shops, the majority of the remainder tend to be occupied by the town's traditional 'small' locally based businesses.

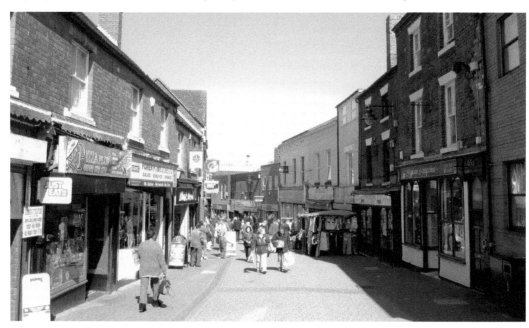

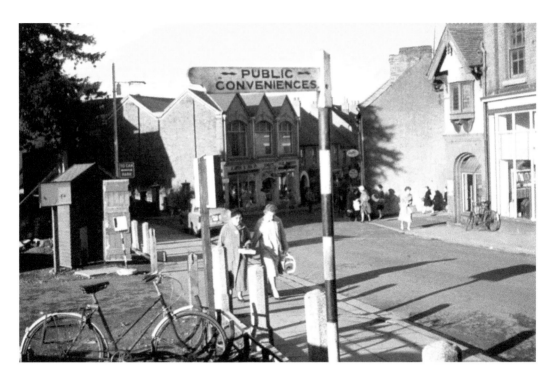

Top of New Street

Just a few metres east of the previous photographs, this is where today's New Street ends, cut away from its earlier extension by the Victoria Road section of Wellington's ubiquitous ring road, which now runs through the waste ground car park on the left and former Frank Sansom's furniture shop on the right, the corner into Victoria Street in the early 1960s photograph below. Aston's former triple-gabled furniture showroom has become a Savers Health, Home & Beauty store.

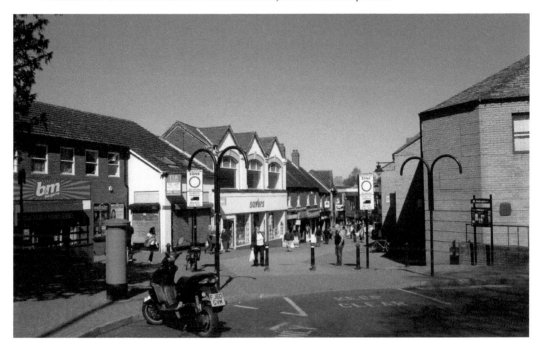

Once New, Now High Street

The top, or most eastern section, of New Street used to end at the Chad Valley Wrekin Toy Works (where Harry Corbett's 'Sooty' glove puppet was made), which is the tall building in the centre of the 1960s photograph. The entrance to the rough car park as seen in the previous photograph is on the right; the advertising hoardings were erected on ground formerly occupied by small cottages, a café and shops. The foreground of the older image is now a section of the ring road; the hoardings area has been replaced by a row of terraced dwellings but Ward's paper shop has survived (jutting out on the left of the older photograph), although the premises are now occupied by Harry Edwards's undertakers and no longer belongs to New Street but constitutes the beginning of the latest incarnation of the High Street.

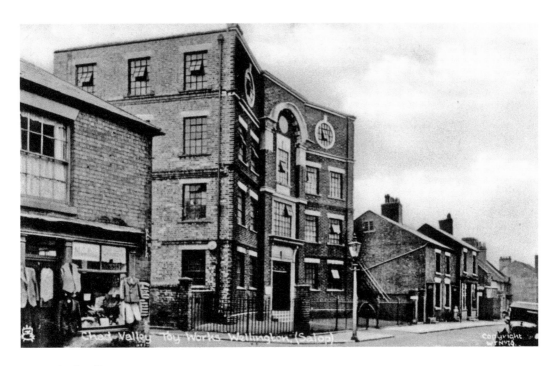

Chad Valley

The Chad Valley building, converted into apartments during 2002, was originally an 1830s Wesleyan Methodist chapel with a small graveyard on the plot of ground now covered by its distinctive early 1920s curved frontage. Madame Davie's 'wardrobe' (second-hand clothing) shop of the 1920s was, along with many other properties in this part of High Street, demolished in the 1960s to clear the ground for council flats and maisonettes. The site of author's family bakery and intervening two cottages beyond the Chad Valley is now incorporated into the terraced row.

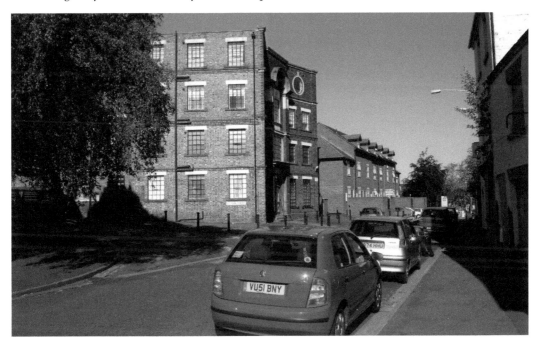

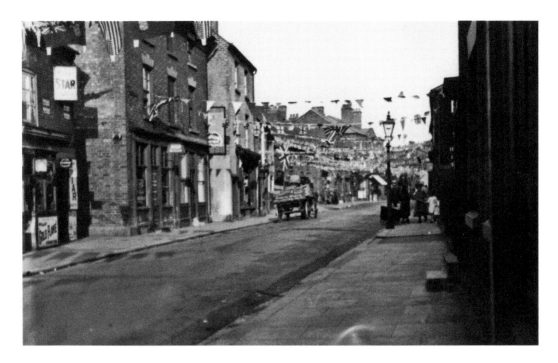

High Street West

The opposite view to the previous photographs shows where New Street used to end and High Street began, at the turning into Chapel Lane (to the left) and the corner into St John Street (on the right). This road used to be the main route into the town centre and had many small shops and a thriving economy of its own, until the ubiquitous ring road severed the connection. Since then, the area has suffered from varying degrees of neglect and the few businesses still in existence are having a difficult time. The 1935 scene shows bunting as part of the celebrations for George V's Silver Jubilee.

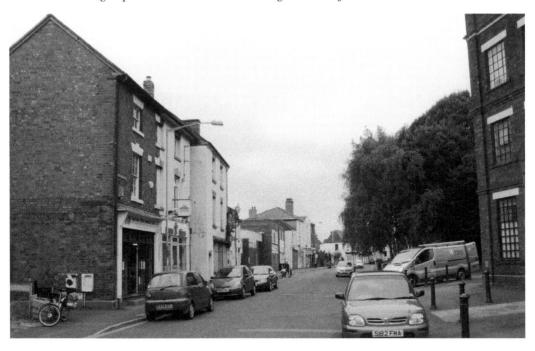

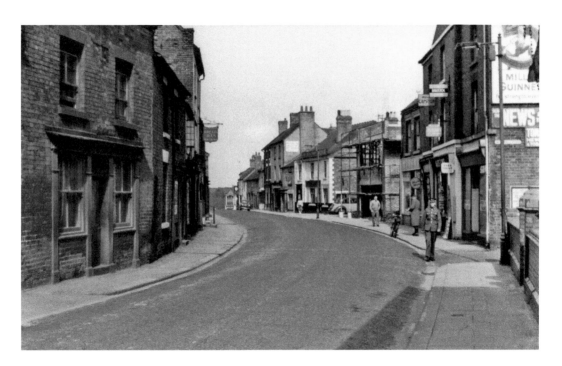

High Street Looking West

View westwards along High Street. In 1960, a new outlet for Shropshire Fireplaces is being built after a group of old cottages were demolished. To the left, many more old buildings (including the Nelson Inn, the sign of which juts out slightly) await their turn, eventually to be replaced by flats and maisonettes. Interestingly, the removal of the poster board on the side of the right-hand building revealed a much older wall-painted advertisement for 'Smith's Stores, Brush & Basket Maker', which may have dated back to the 1870s. When the earlier photograph was taken, Mann's Chinese Laundry occupied the end shop behind the advert, Austin's paper shop was next door and Jervis's Café was next door beyond Austin's.

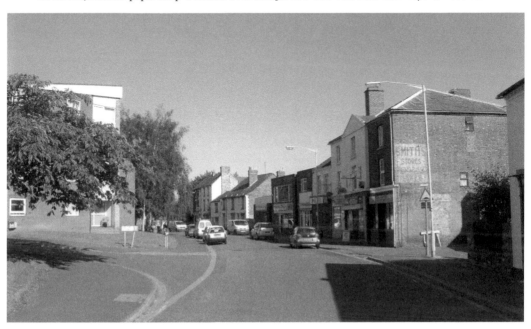

High Street Central

Another scene showing more High Street properties affected by modernisation. The 1940/50 photograph shows a rare view of characteristic small shops and dwellings swept away by Wellington Urban District Council. The move was undoubtedly very welcome for the inhabitants of these small, dirt-floored homes which dated back to the late eighteenth and early nineteenth centuries, as it meant they could be relocated to council estates whose homes had bathrooms and indoor toilets! It's a shame that some of these properties weren't preserved for posterity but, as is often the case, councillors and planners found themselves swept along on a tide of 'progress' and seemed incapable of regarding town development in terms of historical context and continuity. Aspects of the past need to be preserved in places to add a sense of balance, as well as visual interest.

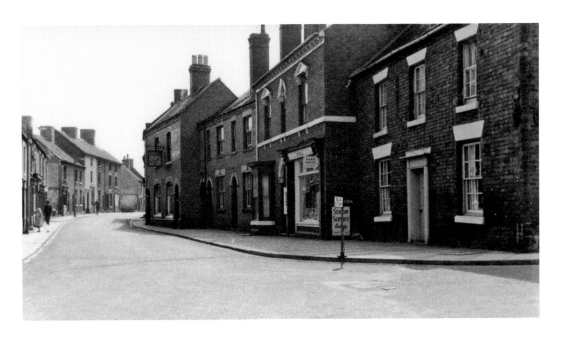

High Street East

A 90-degree turn to the right shows the 'top' or south-eastern stretch of High Street with the turning into New Church Road to the right and the junction with Mill Bank in the far distance. All of High Street was originally part of New Street but was split into two separate roads, probably during the 1870s, to make life easier for post office deliveries as well as general civic administration. All the old cottages and shops on the left disappeared when the council built Lowe Court, a protected dwelling scheme, whereas the Hand and Heart public house on the right was simply demolished. The property on the extreme right of the 1960 photograph was, until about 1930, the Red Lion public house, which was demolished to widen the road and alter traffic flow from down High Street into Glebe Street as part of the new ring road development.

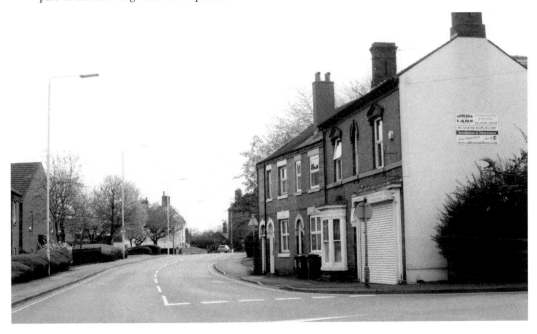

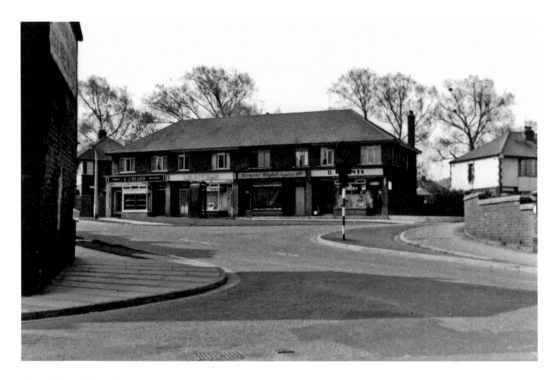

New Church Road

Before the ring road came into being, trade for these shops on New Church Road benefitted from traffic passing by from the Holyhead Road, parts of the Roseway estate as well as custom from residents of New Church Road itself. The subsequent changed road layout, which blocked off access to and from New Church Road at its northern end, has affected their economic viability. The existence of a small car park has helped alleviate the problem to some extent.

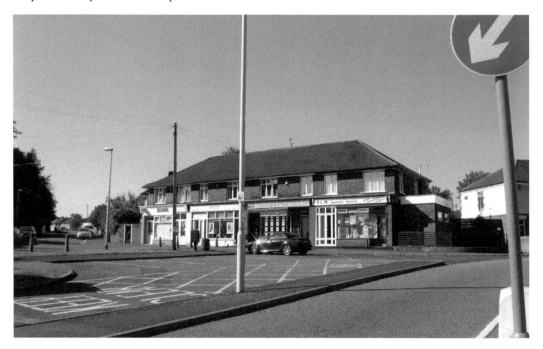

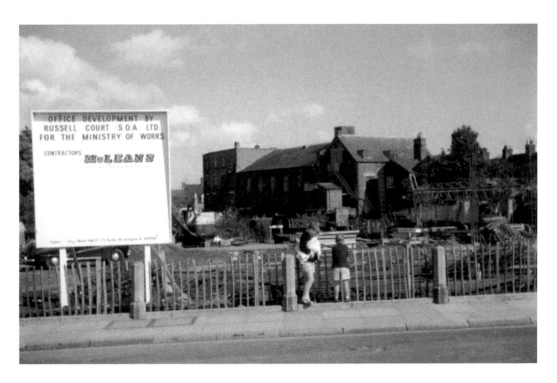

Glebe Street

Formerly known as Jarratt's Lane until renamed by our Victorian forefathers, Glebe Street was, until ring road developments got under way in the late 1960s, something of a backwater. Part of Wellington's 'regeneration' entailed the construction (above, mid-1960s) of a new office block for the Department of Health and Social Security. Now called the Glebe Volunteer Centre, it provides services for various health and community organisations

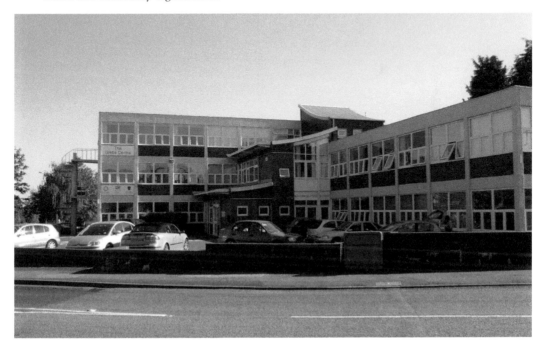

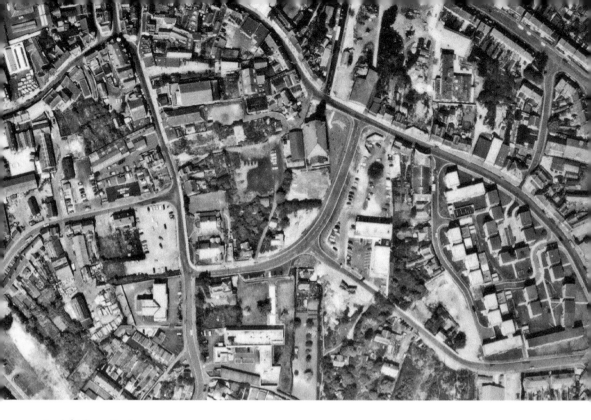

Aerial Views East

Aerial views of properties in the eastern part of Wellington, early 1970s and 2006. In the older photograph, New Street and High Street snake from top left to bottom right, while the first stretch of ring road has already been constructed in the centre. Closer examination shows how many developments and restructurings have taken place over the intervening years.

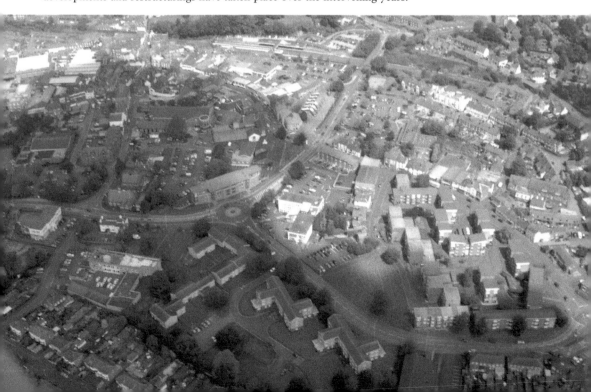

King Street to New Church Road

In these views from (possibly) the 1930s and 1970s, the High School (now New College) in King Street can be seen bottom left. Priority at the junction of King Street and Mill Bank (which runs off to the left) was altered during the early 1970s as another preparation for the ring road, so that traffic flows from Mill Bank into High Street and vehicles leaving or entering King Street have since been required to halt.

Garden allotments in the northern (bottom view) grounds of the high school were introduced by Wellington Urban District Council during the First World War to help combat food shortages, but disappeared after 1939, when an air-raid shelter was constructed in the same general area.

New Church Road lies to the west (right-hand side) of Christ Church, after which the road is named. Comparison of the two scenes reveals how former All Saints Vicarage land to the west of New Church Road is now occupied by the extensive Roseway private housing estate, where building work began in the late 1930s.

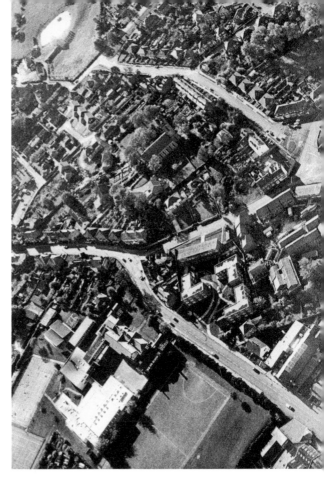

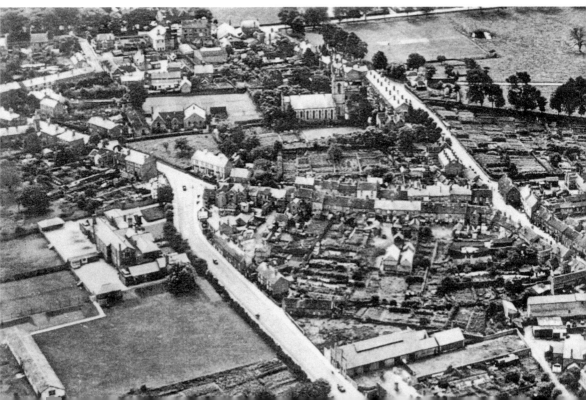

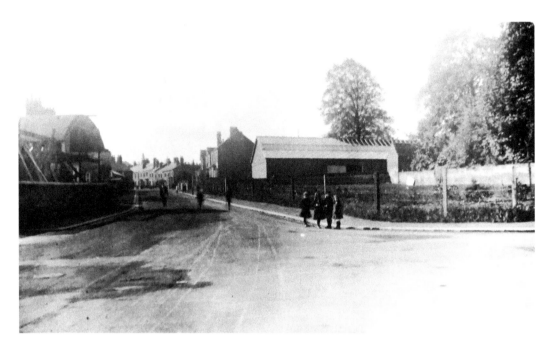

Wrekin Road

Old photographs of Wrekin Road are rare, possibly because it used to be a predominantly residential road. In this northern stretch looking south, Haygate Road leads off to the right. The shed-like building centre right, apparently originally built in the 1920s, has had a variety of uses, including the showroom of motorcycle dealers Wylie and Holland (now operating from Watling Street). On the left, adjacent to the turning into Walker Street, Alfred Roper's building yard was later the site of Bernie Bagnall's ESSO petrol station (now Peter Morris's car dealership). Whereas traffic travelling southwards along Wrekin Road would reach a junction with Holyhead Road, this section (called Water Lane in the 1830s) now carries vehicles away to the left where it joins the Victoria Road part of the ring road.

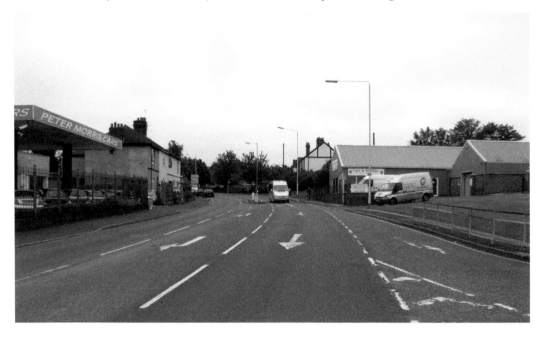

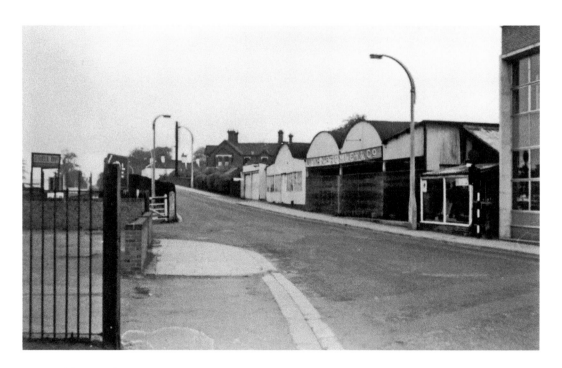

Bridge Road

Bridge road received its name after the arrival of railway services in 1849; prior to that, it was little more than a lane on the western outskirts of the town, not part of the ring road as it is now. Market Street runs off to the right, whereas a new housing estate on land formerly occupied by the gasworks, Groom's Shropshire Works timber yard and the railway goods yard is reached by turning left into Groom's Alley. Groom's was, in the latter half of the nineteenth century at least, the largest importer of foreign timber in the country.

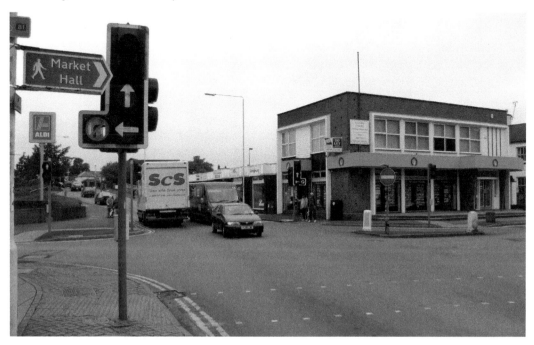

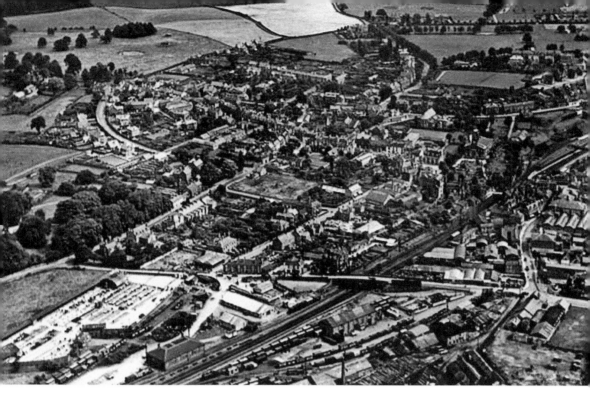

The Smithfield from the Air

Wellington's second and main Smithfield livestock auction facility opened in 1868 and remained in business until 1989. It had become the largest Smithfield outside London, thanks to the business acumen of John Barber, his sons and successive partners in Barber's Church Street business. The Smithfield lay on the north-western length of Bridge Road and even had its own sidings in the railway goods yard, as shown in the early 1960s east-facing photograph. By contrast, in the 2006 scene (facing south) the entire area is now the site of Morrison's supermarket.

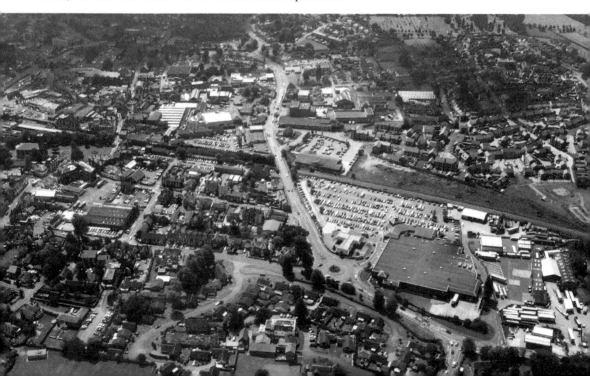

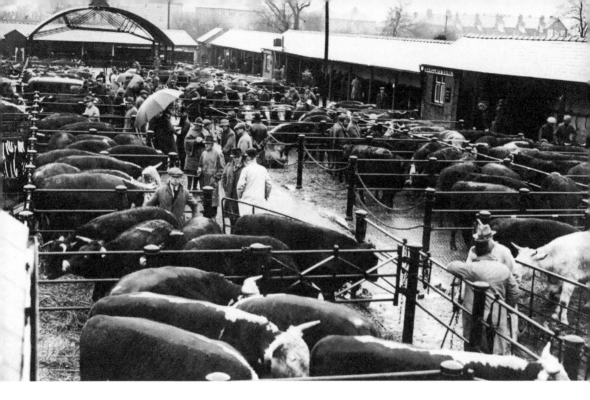

The Smithfield down to Earth

Cars and shoppers in a hurry occupy an area once dominated by sheep, cattle and pigs at the Smithfield auctions held every week. These auctions attracted an incredible number of folk, including buyers, farmers, farmers' wives, families and farmhands, who took the opportunity to visit Wellington's shops and pubs, or one of the agricultural manufacturing firms (like John Bromley's in Bridge Road) or seed merchants (Edward Turner's). The whole town economy flourished and prospered as a result. For more information on the Smithfield and the effect Barbers had on the town's development, see *The Story of Barbers, Established 1848* by this author.

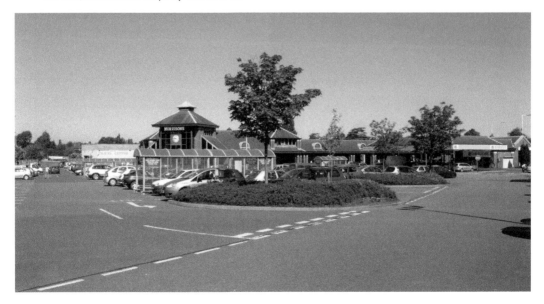

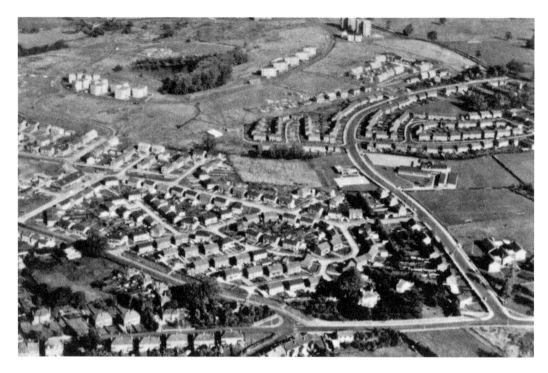

North Road and Dothill

Since the 1950s, much of the land comprising the North Road and medieval Dothill Park area has been developed into a massive housing estate. North Road swings from bottom right to top right in the early 1960s view, and from bottom left towards bottom right in 2006. Dothill pools are visible in both scenes.

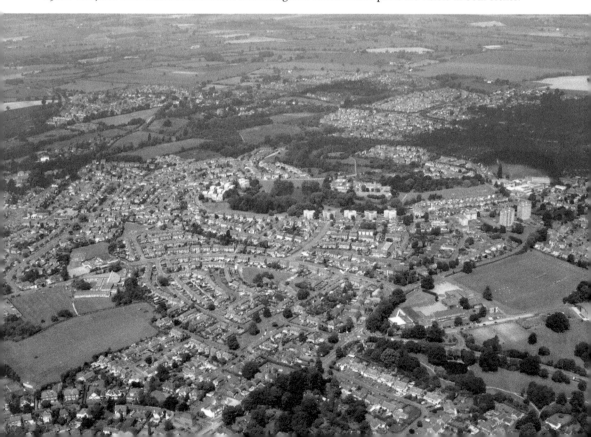

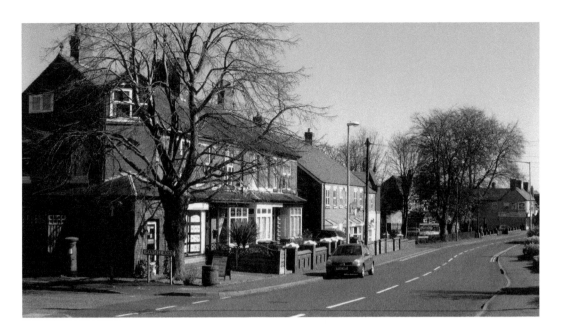

Haygate Road

This road leads into Wellington from the western edge of the town from its junction with Holyhead Road. Until the creation of the town cemetery in 1875, it didn't seem to have a name (although its eastern extremity was called New Town) whereupon the part shown in these contrasting photographs from 1930s and 2015 became Cemetery Road, whereas the remaining length running from here to Holyhead Road was known as Haygate Road. At some point (probably around the time of the First World War), common sense prevailed and the whole road became Haygate Road. In these views, the property on the corner with Mansell Road has been occupied by estate agents Weston Hare for over ten years, having previously been a general stores, although the line of Haygate Road on the right has been straightened slightly when newer houses were built from the late 1960s on land formerly belonging to large villas.

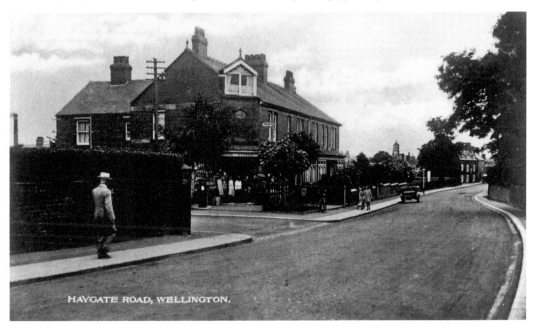

HAYGATE ROAD, WELLINGTON.

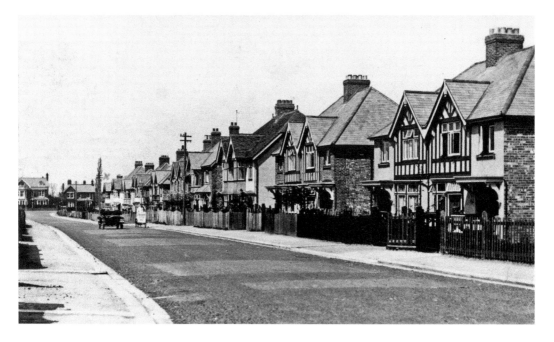

Herbert Avenue

The 1930s saw an increase in the number of private dwellings built in the town to satisfy demand created by aspiring middle-class workers and semi-professionals. Herbert Avenue was one of the most prestigious developments of the time, although it was known by more perceptive folk as 'Bread and Dripping Lane', based on observations that those who bought these desirable residences couldn't afford to eat decent meals after encumbering themselves with mortgages. In the older photograph, a Sidoli's 'Stop-me-and-buy-one' ice cream bicycle can be seen next to the car parked in the middle of the road.

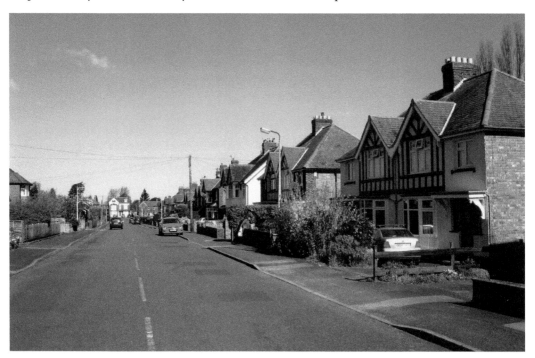

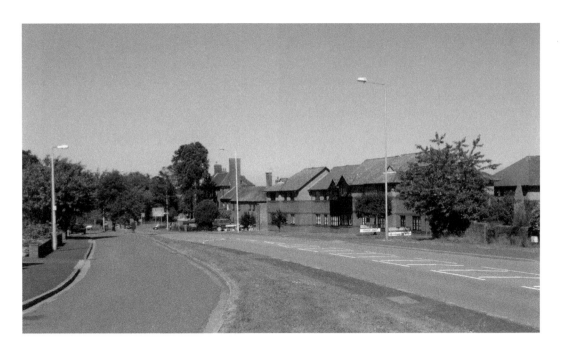

Holyhead Road

This road constitutes the main east–west route along the southern edge of Wellington. Called Watling Street since ancient times, some stretches (such as this on the western extremity of the town) are known as Holyhead Road in view of the fact that the road leads to Holyhead on Anglesey and provides an important transport link to Eire. The Falcon Inn (1971, below), positioned at the junction of Holyhead Road and Haygate Road, has seen life as a farm (Hay Gate Farm) and a coaching inn (Hay Gate Inn, then the Royal Oak, later called Falcon Inn) on the Shrewsbury to London route, which ceased in the early 1850s when railway travel made journeys on uncomfortably slow stagecoaches suddenly less attractive. It is now The Old Orleton restaurant; its stables and outbuildings have been converted into apartments.

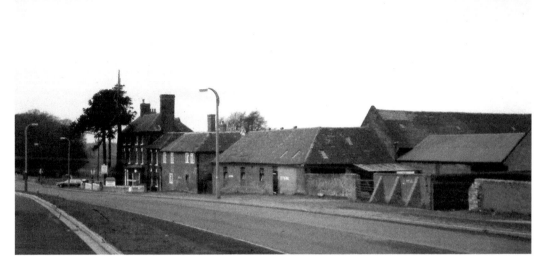

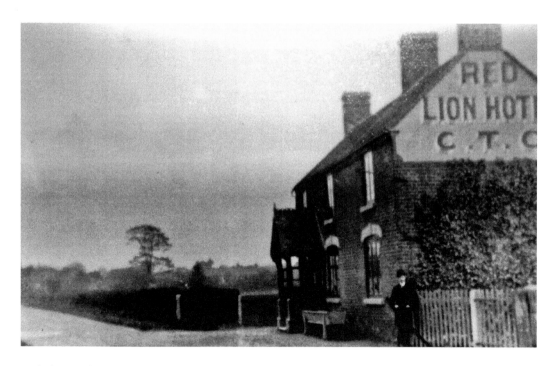

Red Lion, Holyhead Road

The Red Lion on Holyhead Road was, some 100 years ago, surrounded by fields. The main road itself had become little more than a country lane after stagecoach services declined and it remained so until motorised vehicles gained dominance from about 1920 onwards. Whereas the Red Lion used to cater for Cyclist Touring Club members and horse-drawn carriages conducting leisurely journeys through the quiet countryside, the hotel and its neighbouring service station have adapted to suit modern needs. After decades of traffic jams blighting every Bank Holiday Monday, the arrival of the M54 in the 1970s has effectively replaced this as the main arterial route and reduced the amount of through traffic accordingly.

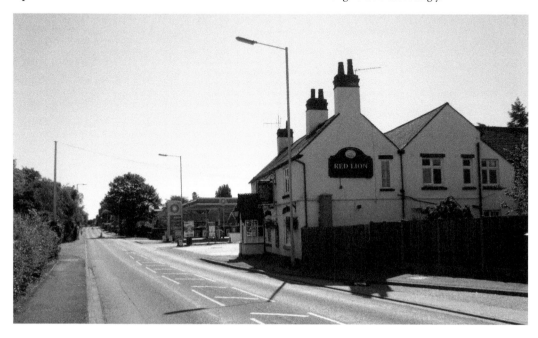

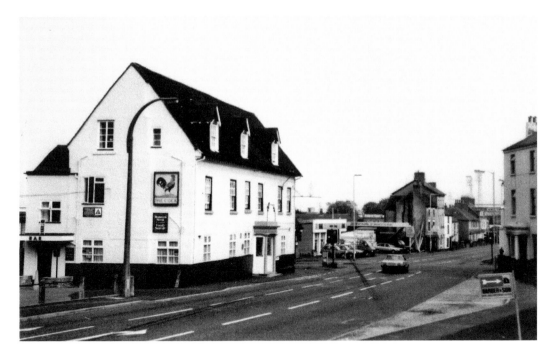

Watling Street

A short stretch of Holyhead Road retains its ancient name of Watling Street in what used to be a separate township from Wellington until towards the end of the nineteenth century. The Cock Hotel, an old coaching house, is situated at the bottom of Cock Hollow on Holyhead Road, with Watling Street continuing to the east. Mill Bank (left turn after the hotel) leads to Wellington centre, while Dawley Road is to the right at the traffic lights.

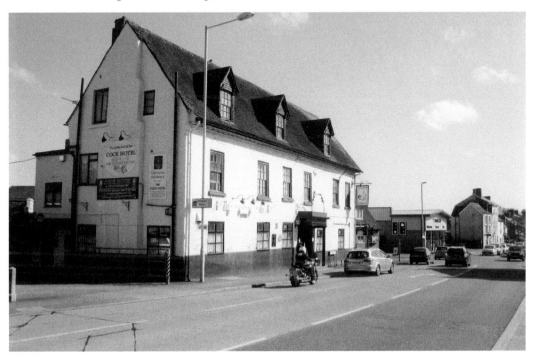

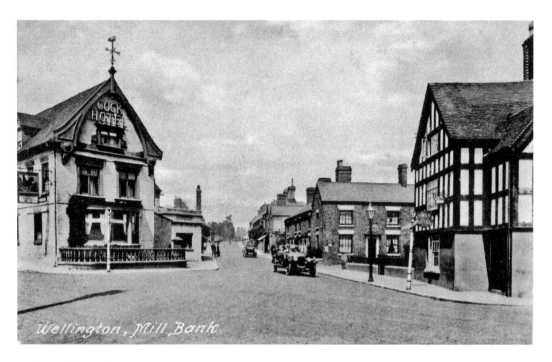

Wellington, Mill Bank

Cock, Anchor and Swan

The Cock Hotel and Swan Hotel lie on opposite sides of the entrance into Mill Bank (once known as Wind Mill Bank after a medieval mill serving the town of Wellington until the middle of the nineteenth century). The Cock is now renowned for its real ales. The Swan, rebuilt in 1960 because the (possibly) original fourteenth-century inn was on the verge of collapse, had accommodated Humphrey, the ghost of an ostler, whose spirit was released during an exorcism shortly before the old inn was demolished. In the 1930s photograph, the Anchor Inn can be seen at a right angle to Mill Bank to the left of the Swan. The Anchor had been in business since before 1828 and closed in 1916. A victim of the First World War, whose Defence of the Realm Act ('DORA') placed so many restrictions on trade that it was forced to close, it was eventually demolished to make way for an extended car park to the Swan.

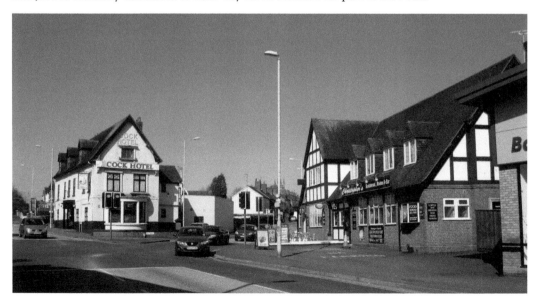

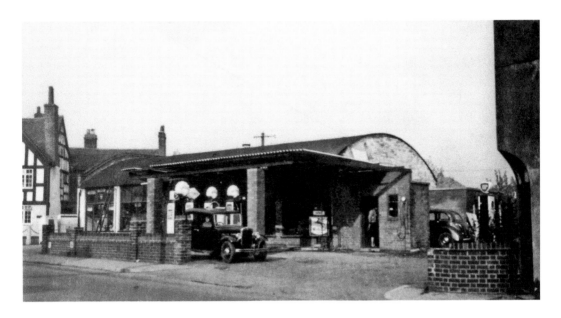

From Petrol to Plumbing

The Swan Hotel is to the left of the late Patrick ('Pat') Reade's garage in Watling Street. Pat's father started the business in the early 1920s. The original premises were eventually rebuilt and its forecourt extended to incorporate the former Prince of Wales public house, whose corner-entrance doorway can be seen on the extreme right of the 1940s photograph. The business later became a Renault dealership with a large showroom. Following Pat's retirement, a partnership comprising Graham (now deceased) and Anne Wylie, and Clifford and Vera Holland replaced the garage with their own motorcycle showroom, which opened in September 1998; they had previously occupied Harry Stanford's motorcycle workshop in Wrekin Road. After moving to a former garage in King Street – and following considerable refurbishment – Farr & Harris relocated to this site from their former showrooms and plumbing merchants on the High Street in December 2013.

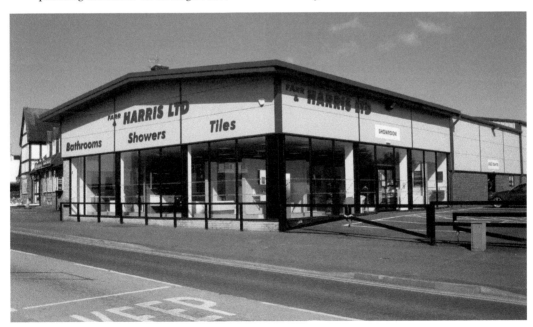

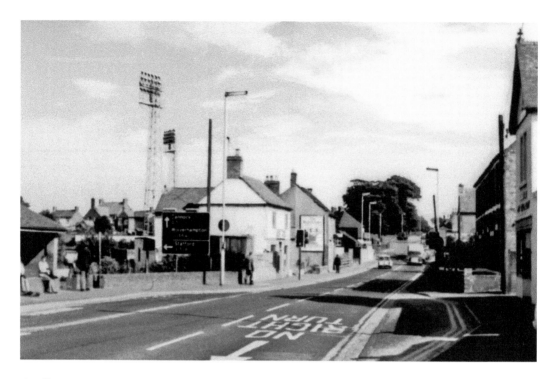

Watling Street East

The eastern end of Watling Street, looking east with Bennetts Bank in the distance. So much has changed on the left over the last fifty years. Floodlights to the Buck's Head football ground, home of Wellington Town Football Club, were replaced when a new stadium and complex was created for Telford United FC, which suffered from financial problems before the grounds were adopted by AFC Telford United. The bus stop on the left has been moved 100 metres closer to the White House Hotel whose buildings dominate the modern scene.

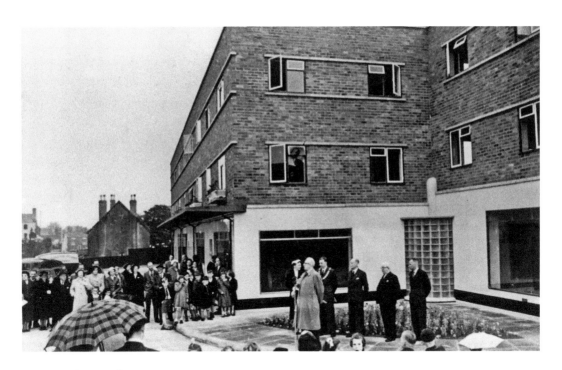

Dawley Road

The creation of a massive 700-house estate on both sides of Dawley Road at Arleston was one of Wellington Urban District Council's major achievements; it provided some 3,000 people with decent living accommodation in post-war Britain. In addition to building homes, the council recognised the need to provide a small shopping centre; Cllr Alan Hartland officially opened this block of nine shops in 1953.

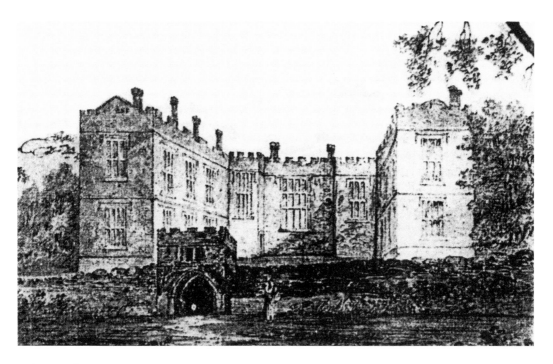

Apley Castle

There have been three Apley Castles north-east of Wellington. The illustration above is of the second. Started in 1567 and completed in 1620, it witnessed several skirmishes during the English Civil War. The third and final 'castle' (below, as seen around 1900) was constructed following St John Charlton's death in 1776; he had been Sheriff of Shropshire in 1757. Regrettably, the estate was sold and the castle demolished in the mid-1950s.

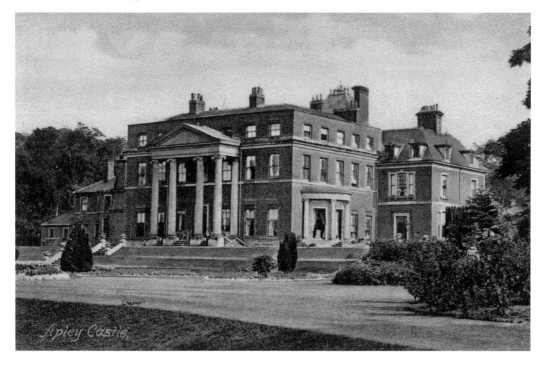

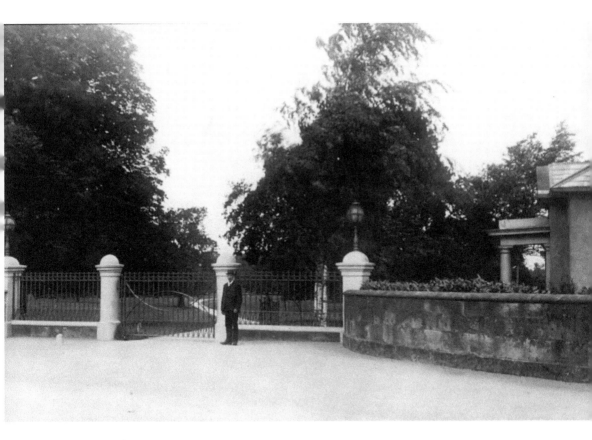

Apley Castle Drive

The grand Whitchurch Road entrance gate to Apley Castle and its long, winding drive have long since disappeared, although the former lodge to the right of the gate still exists as a private dwelling. The site now comprises a 'pimple' roundabout junction leading from Whitchurch Road along Apley Avenue towards the Princess Royal Hospital and Whitchurch Drive.

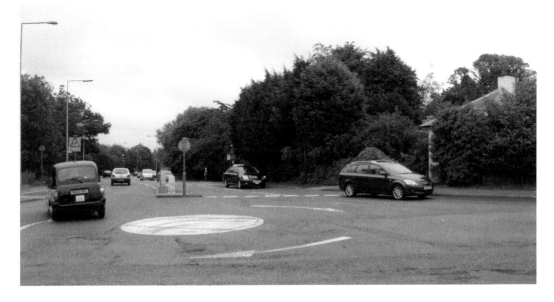

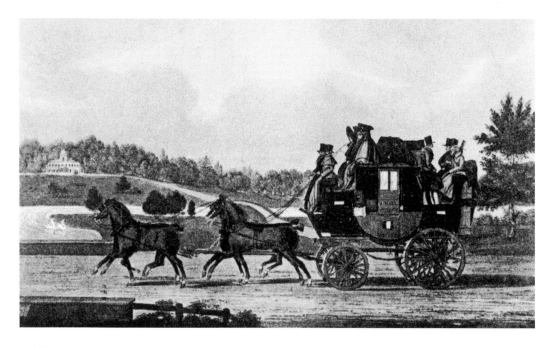

Public Transport

Until the arrival of the railway in Wellington in June 1849, ordinary people seldom travelled away from the town or village in which they worked. Those that did and could afford to caught one of several stagecoaches (so called because their horses had to be changed for fresh ones at various 'stages' along the route). The *Wonder* covered the journey from Shrewsbury to London (in sixteen hours!) from the late 1820s until the 1840s. Its staging post at Wellington was the Hay Gate Inn (renamed Royal Oak, then Falcon in the 1830s). In general terms, the next period of regular coach (or 'bus') services came in the early 1930s, when Victoria Street (below, 1960) was a major terminus for local routes.

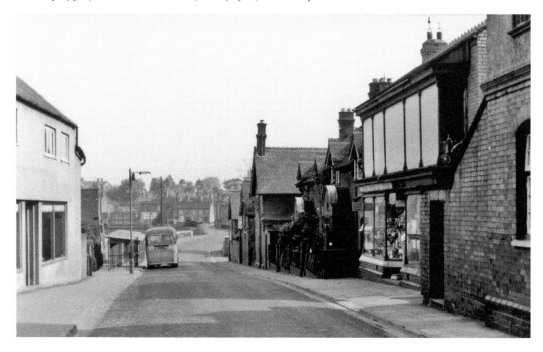

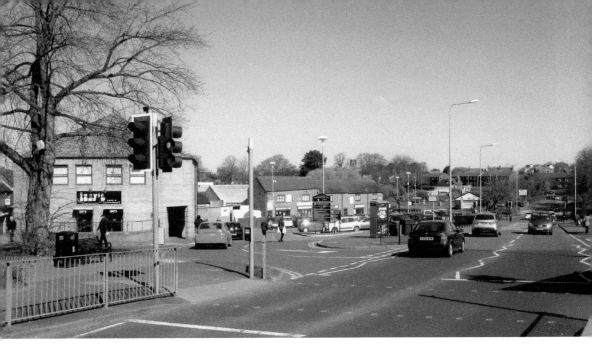

Modern Bus Station

Following the arrival of the ring road in the 1970s, properties along Victoria Street were demolished and replaced by a dividing fence and footpath between a new bus station and the Victoria Road portion of the ring road itself (as seen above). Those properties comprised, prior to 1887, a long row of cottages known (since at least the eighteenth century) as Nailors' Row, where nailmaking was a major domestic industry. This bus station relocated to the site of the Parade car park (seen below) in June 2009 as part of a scheme to consolidate the town's rail and bus stations to form a transport hub, since when the previous bus station was converted into the Nailors' Row car park.

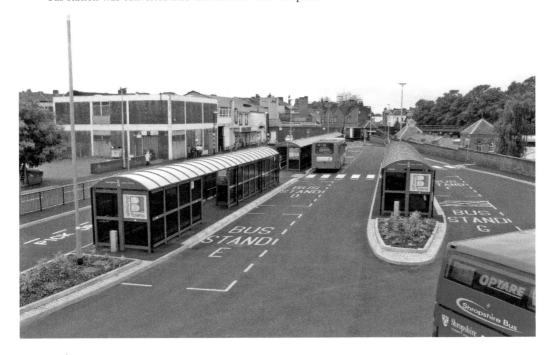

Charlton Street

Whereas the old Victoria Street terminus was used by local bus operators (Jervis's, Martlew's, Brown's, Cooper's, etc.) until their services were absorbed into Tellus routes (which arrived at about the same time as the Telford conurbation became a reality), competition on some routes came from the Midland Red Omnibus Co. of Birmingham, whose local depot was in Charlton Street from the 1930s. Although Midland Red services covered longer routes to places further afield, like Wolverhampton and Shrewsbury, the first few miles of those routes coincided with those of small bus operators serving local villages and townships, giving rise to accusations of customer poaching and unfair practices. In more recent years, local bus services were provided by Arriva Midlands, although the site is destined for house building as the depot for the bus company relocated to Stafford Park near Telford Shopping Centre in 2012.

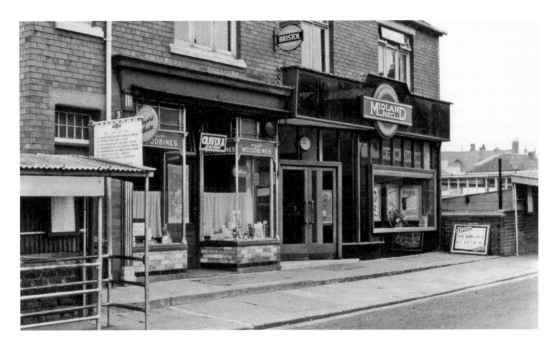

Queen Street

Midland Red's booking and information office was around the corner from Charlton Street in Queen Street, where its 'cattle pen' passenger shelters with metal poles and corrugated iron roofs provided minimal protection against the elements. They were removed when Arriva Midlands took over. The former office is currently a tattoo studio, although the former cafe next door has become Mukaase, an Afro-Caribbean eat-in or takeaway shop.

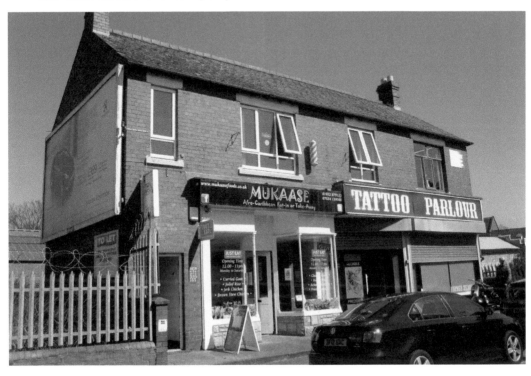

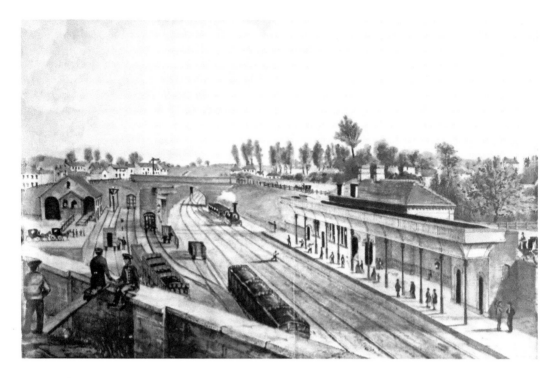

Railway Station

Railway services had an immediate effect on public travel from the moment they reached Wellington in June 1849. Initially, the line ran from Shrewsbury to Oakengates via Wellington and, within a few years, further lines made travel to major towns and cities, as well as local villages and places of work, an economic reality. Rail travel continued to dominate long-distance public transport until Dr Beeching's disastrously ill-conceived cuts of the early 1960s. By good fortune and many protests, Wellington continues to benefit from passenger train services.

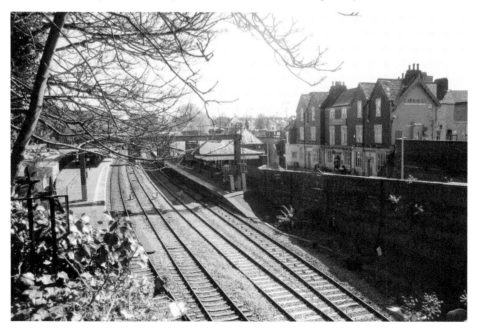

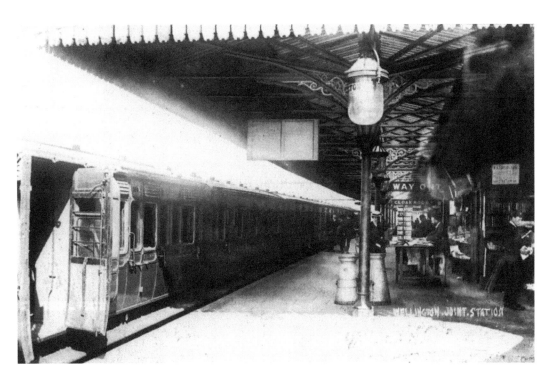

Station Platforms

Wellington passenger station was once a major junction providing access to lines serving Shrewsbury and Mid and North Wales, Market Drayton and the North, Stafford, Wolverhampton, Birmingham and London as well as branch lines to, for example, Much Wenlock and South Shropshire. Now it is simply a passenger station on an east–west route. One hundred years separate these two photographs.

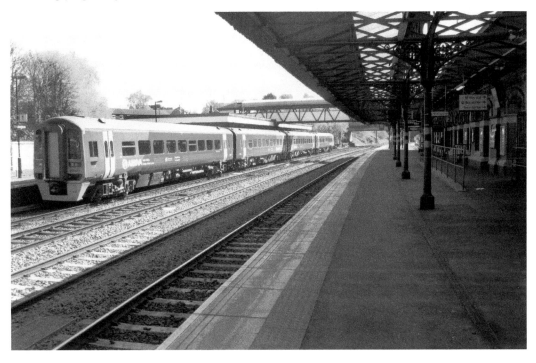

Vehicle Hire

Visitors and local residents couldn't afford their own vehicle until relatively recent years. In the late 1800s, the Ercall Hotel in Market Street hired out a wide range of carriages (with horses). In 1960, Brown's Taxis in New Street provided a similar car hire as well as a taxi service.

Christ Church

Over the years, Wellington has been blessed with a variety of churches and other places of worship to suit most tastes and faiths. All Saints parish church is, of course, the oldest in the town to survive.

When the population of Wellington increased during the early 1800s, newer concentrations of inhabitants tended to be located some distance away from the parish church. Christ Church was consecrated in 1839 (although its foundation stone says 1838) as a 'daughter church' or 'chapel of ease' to All Saints because it was located nearer to where some people lived and was thus easier to attend services. A century separates these two photographs, and very little appears to have altered the main entrance and western tower visually, although a new face to the clock (originally installed in 1860) was fitted in 1995. For more information on this fascinating church, see *The Story of Christ Church* by this author.

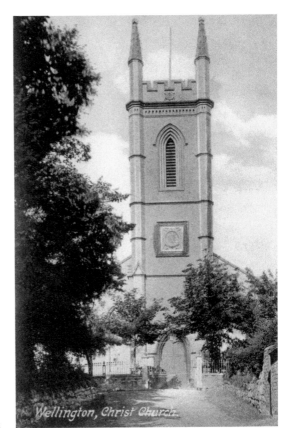

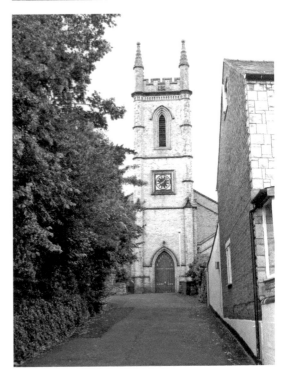

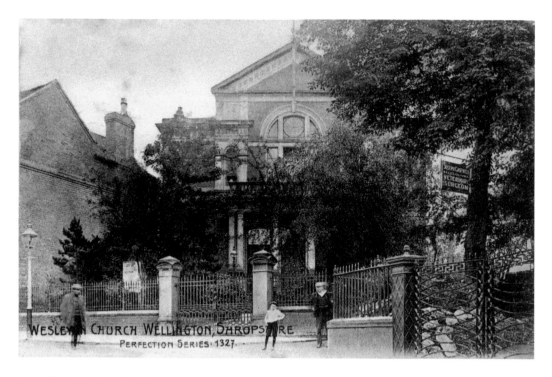

New Street Methodist Church

The Wesleyan Methodist church was built in 1882 to replace a former chapel further along New Street which subsequently became the Chad Valley Wrekin Toy Works. Wesleyan Methodism at this time dominated the religious and political scene to the extent that many Town Commissioners' and, later, Town Council decisions were made here. This building was demolished in 2003 and replaced the following year by a smaller, more adaptable church.

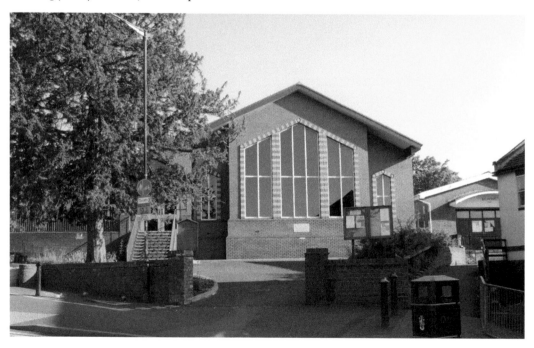

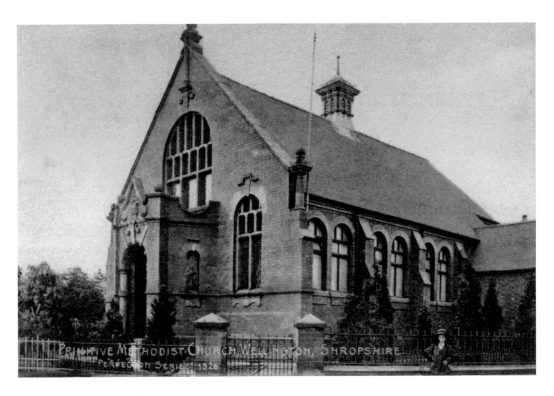

Tan Bank Methodist Church

Not to be outdone, Primitive Methodists raised the capital to build their own new chapel and Sunday school room at the junction of Tan Bank and (then) Glebe Street (now a part of the ring road). After the Wesleyans in New Street and the Primitives in Tan Bank merged in the mid-1960s, these buildings became home to the Methodist Youth Club until it wound up in the late 1970s. The chapel has become the Telford Central Mosque while the Sunday school room is now the Bethel United Church of Jesus Christ Apostolic.

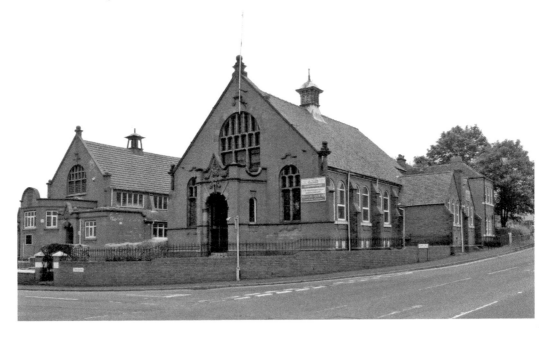

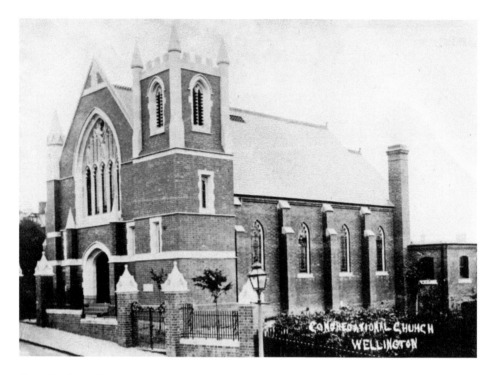

Constitution Hill

The Congregational church on Constitution Hill was erected in 1900 following a successful appeal to revive its fortunes. Services had formerly been held in their church on Tan Bank which had been partially paid for by Market Square printer Robert Houlston in 1825 and closed for a variety of reasons, not least dwindling congregations, in 1884. It subsequently became the Union Free Church.

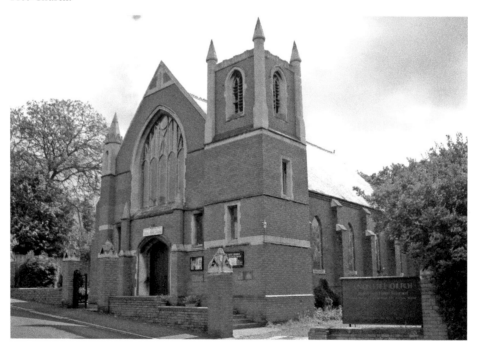

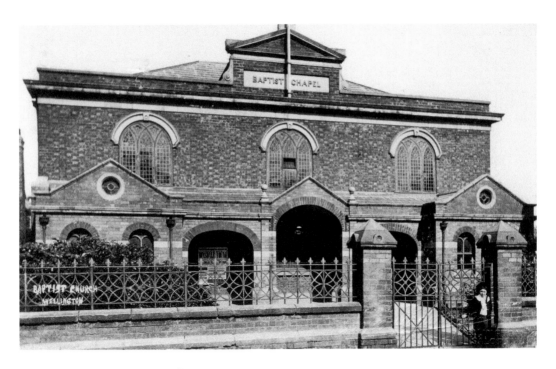

From Chapel to Car Wash

A Baptist chapel in King Street was originally erected in 1807; it was demolished and rebuilt in 1828, then enlarged in 1897. By 1926, it had closed and become Norah Wellings' Victoria Toy Works which traded until 1959. In the interim, Norah's high-quality dolls gained worldwide fame; they continue to fetch high prices at auctions. The factory was demolished to make way for an ESSO petrol station which has also since been demolished. One of several car wash enterprises to spring up in the area in recent years has occupied the site for the last two years.

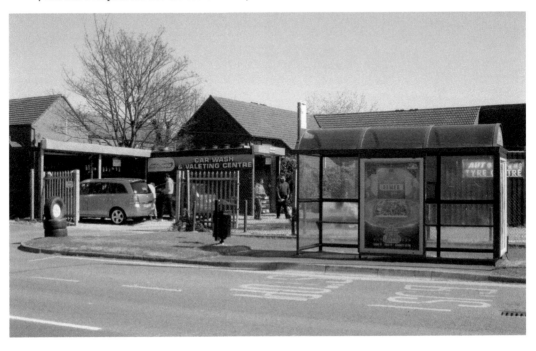

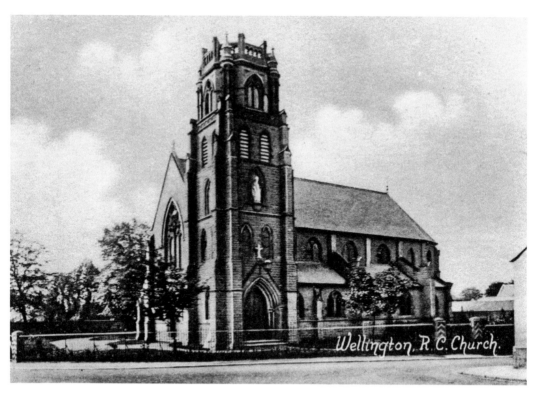

St Patrick's Catholic Church

St Patrick's Catholic church at the corner of King Street and Plough Road (centre right, named after the Plough Inn on the right) was constructed in 1906 as a replacement for an earlier church on Mill Bank which subsequently became a Roman Catholic school (also bearing St Patrick's name).

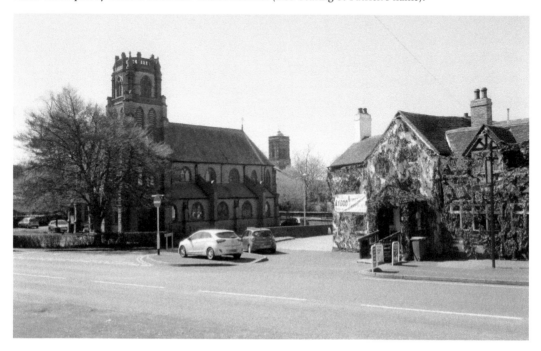

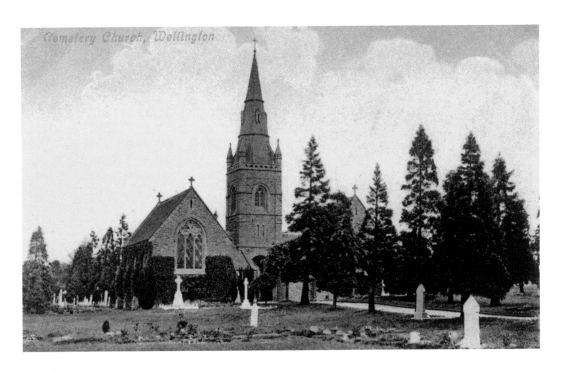

Cemetery Church, Wellington

Wellington Cemetery

By the middle of the nineteenth century, the graveyard at All Saints parish church had become overcrowded to the point where digging new graves often entailed exposing the remains of earlier burials. To rectify matters, a municipal cemetery with a non-denominational chapel was created in 1875 on land off Haygate Road. Although most interments were ostensibly of Church of England believers, sections of the graveyard were allocated to specific denominations, as if to affirm that if they congregated in groups during their lifetimes, then they could expect to congregate with the same people in the afterlife.

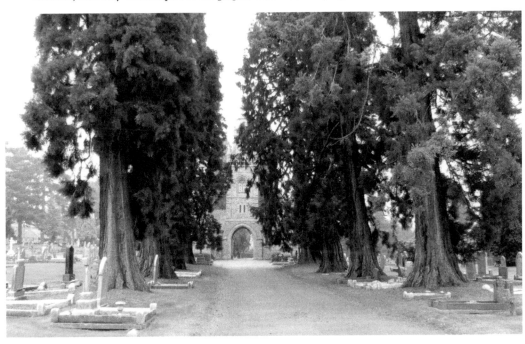

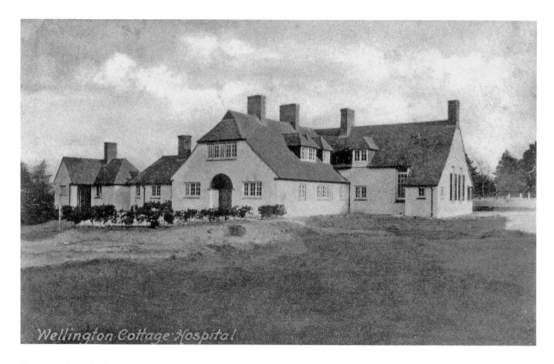

Cottage Hospital

The Cottage Hospital off Haygate Road was donated to the people of Wellington in 1914 as a bequest in the will of the widow of John Crump Bowring, a late Victorian fishmonger and fruiterer. It had opened a year earlier. The hospital specialised in treating minor injuries, many sustained in the workplace. It was later absorbed into the National Health Service and, after much wrangling and a public appeal, is now occupied by Wellington Cottage Care which caters for adults with nursing needs on a daily basis. It has an excellent reputation and, since it is a charitable trust, is able to continue through donations from businesses and individuals alike.

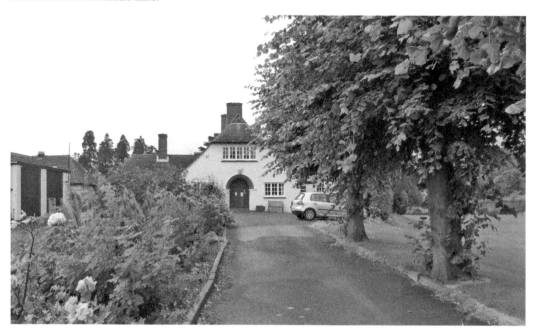

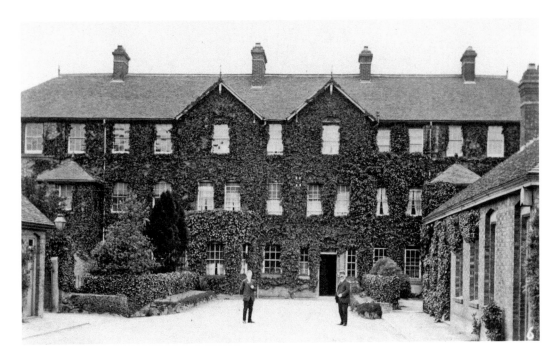

Wrekin Hospital

The Wrekin Hospital, now a Morris Care Home, began life as a new Union Workhouse in 1875, intended partly to provide better facilities for its unfortunate inmates together with a modern mortuary, and partly to relocate the whole institution well away from the town centre. Its hospital facilities were well used during the First World War and, in common with so many other former workhouses throughout England, it eventually became a permanent hospital serving the local community, only to be replaced in February 1989 by the Princess Royal Hospital on land that was previously part of the Apley Castle estate.

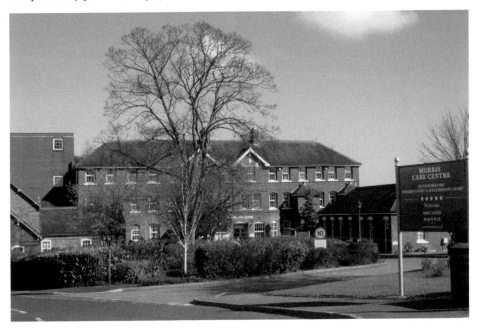

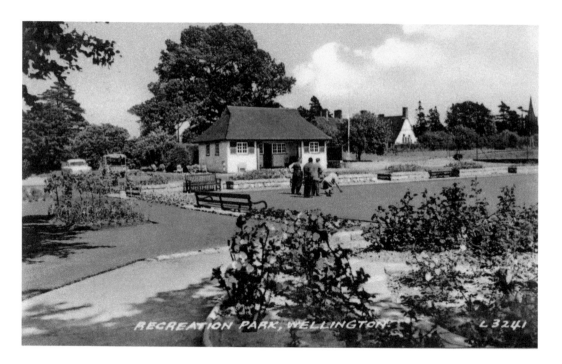

Bowring Recreation Park

This public park was bequeathed to Wellington's townsfolk by the same John Crump Bowring whose money paid for the Cottage Hospital, which is visible to the right of the park's pavilion in the 1950s scene below. The park, which opened in 1913, probably reached a peak in popularity during the 1950s and 1960s, when its tennis courts, bowling green and children's paddling pool gave a great deal of pleasure to visitors. Its grounds have also been used for amateur football and cricket matches as well as events with more general appeal, like the Lions' Day on Wheels. Regrettably, the pavilion has suffered attacks from arsonists over the last twelve months, despite being rebuilt following a devastating electrical fire in 2012.

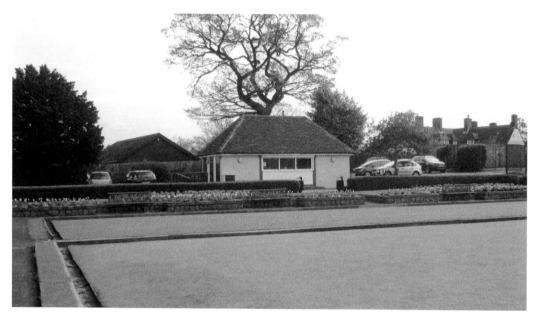

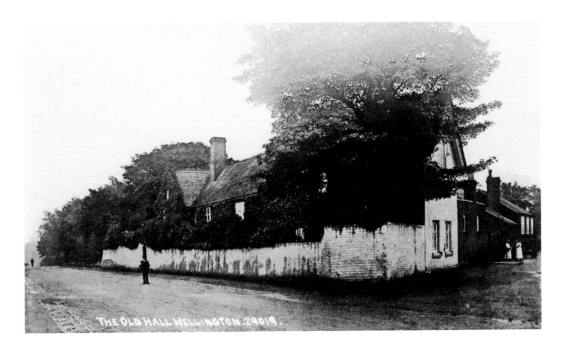

Old Hall

The more ancient parts of Old Hall, Holyhead Road, date back to about 1480 when Edward Forester, warden of the Wellington Haye, part of the Forest of Mount Gilbert, lived here. It had been much enlarged by the time it became Joseph Cranage's Old Hall School in 1845. Cranage's family continued to run the private school until 1926, when it was purchased by Ralph Hickman; it was enlarged again and became a well-regarded preparatory school until it relocated to a site near Wrekin College. The buildings and land have undergone extensive development by Shropshire Homes who have created 'Old Hall Gardens' as a small housing estate.

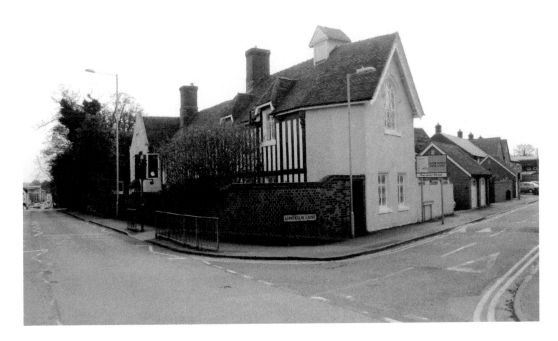

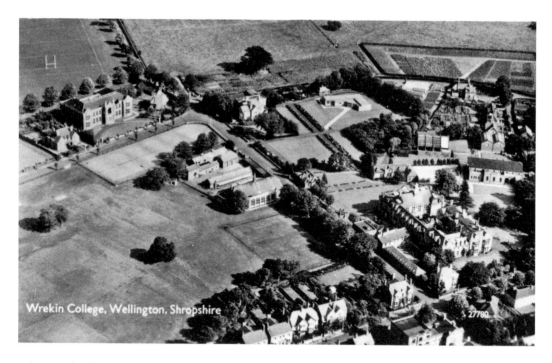

Wrekin College, Wellington, Shropshire 27780

Private Schools

The new Old Hall school is an ultra-modern development off Stanley Road and opened in 2006 with Martin C. Stott as its headmaster. Part of the premises (those on the right in this photograph) are occupied by Daisy Chain Nursery, which prepares its children for 'moving up' to the Old Hall school itself when they are old enough. Wrekin College (above) was originally called Wellington College when founded by John Bayley in 1880 but was renamed in January 1921 to avoid confusion with the more famous Wellington College in Somerset. The amount of land and the number of buildings belonging to the college have increased dramatically since those early days when its assets comprised just two semi-detached dwellings in Albert Road.

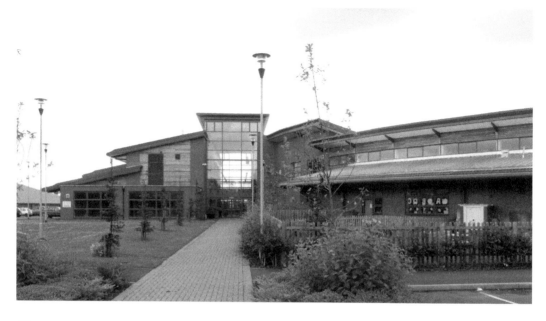

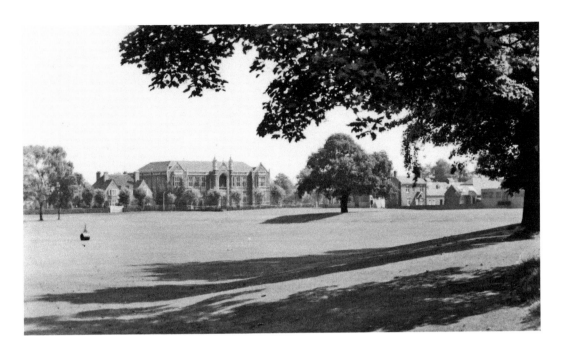

Wrekin College

It's little wonder the grounds of Wrekin College on the outskirts of Wellington maintain a charm of their own, distinct from anywhere else in the town. The 1950s photograph of the cricket field exudes the peace and tranquility of a bygone age ... yet, as the 2009 scene taken from the opposite direction shows, the atmosphere still exists, even if the frequency of play does not. Times change, and so has the constitution of the college which was, for most of its life, a boys-only institution. It now accommodates girls as well as boys and continues to achieve exceptional examination results in a semi-rural setting conducive to academic achievement.

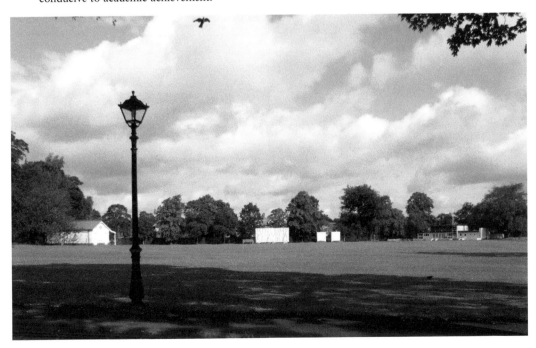

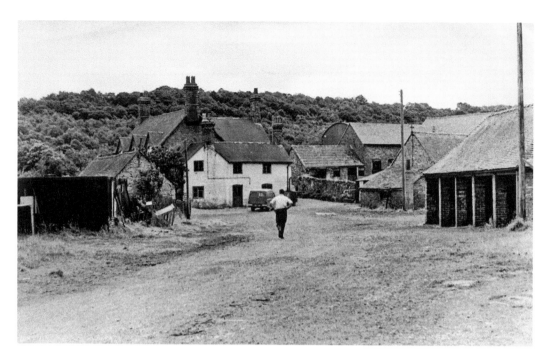

Steeraway

Steeraway Farm lies at the southern end of Lime Kiln Lane, known for several hundred years as Woodward's Shute. The farm itself isn't particularly remarkable, although its setting is, lying as it does in a hollow between the Short Woods (where adit and other shallow coal mining operations have left their mark on and below the surface) and a pair of lime kilns which, members of the older generation maintain, were still in use as late as 1930. Limestone was extracted from the hillside behind where the photographers stood to take these photographs since well before the nineteenth century (even in 1814 they were described as 'Old Lime Works') for use in nearby blast furnaces, building and on farms.

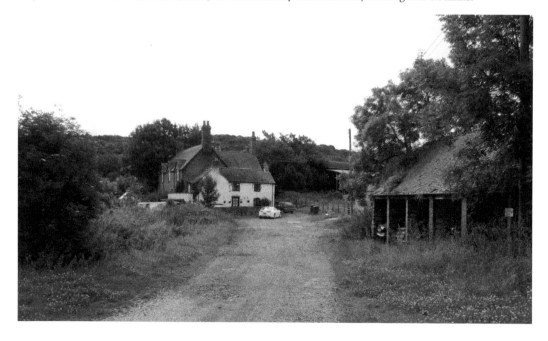

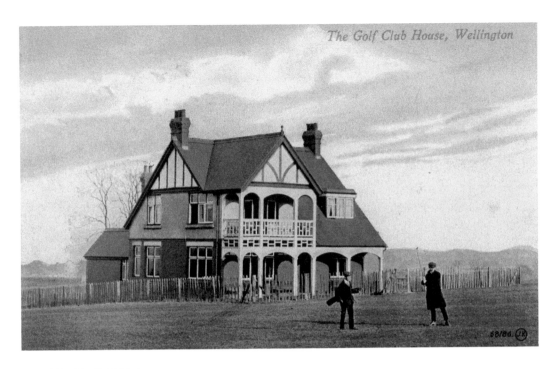

The Golf Club House, Wellington

Wrekin Golf Club

Golfers began playing on links near Wrekin (then Wellington) College. By 1907, Wellington Golf Club (as it was then called) relocated to a nine-hole course near Steeraway Farm, while at the same time negotiating with Lord Forester to create a 'proper', more adventurous course on and around the slopes of the Ercall hill. Work on the new Wrekin Golf Club began in 1908 and the Steeraway course was abandoned by 1910, by which time a new clubhouse (above) had been built. The next major development came in the 1970s when construction of the M54 entailed the loss of land and the old clubhouse, which in turn led to improvements to Golf Links Lane and construction of the present clubhouse. Wrekin Golf Course is considered to be one of the prettiest in the country.

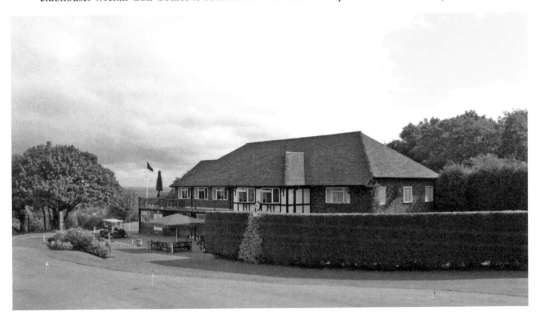

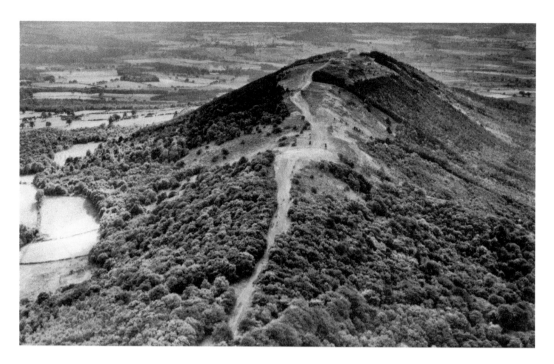

The Wrekin Hill

Wellington has a long association with the Wrekin Hill, which it regards as its 'own little mountain'. In fact, the town was once known as Wellington-Under-the-Wrekin to distinguish it from Wellington in Somerset. The hill was occupied some 3,000 years ago until shortly after the Roman invasion when its Iron Age hill fort fell into disuse. The earthworks can be seen at the top of the hill in the late 1930s photograph, while the 2006 view gives a better idea of the long haul to the summit, with the famous Halfway House just visible in the clearing at bottom right. *The Wrekin Hill* by this author gives a comprehensive history of this famous landmark.

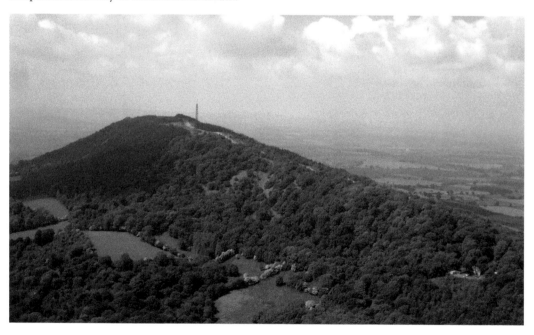

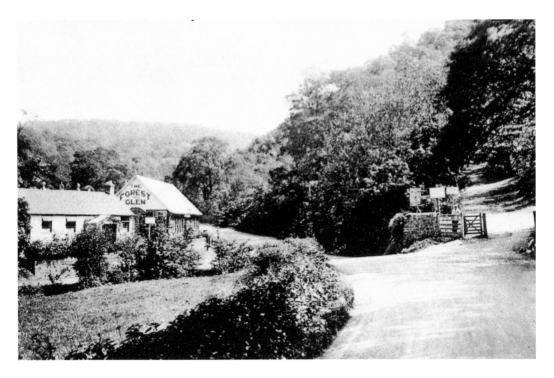

The Forest Glen

The main path up The Wrekin Hill starts at the Forest Glen which, for a hundred years from 1889, was home to Henry Pointon's Forest Glen Pavilions, serving refreshments to walkers, cyclists and motorists who came in their droves to enjoy clean air and exercise. The Glen was also a popular venue for evening dinner dances and wedding receptions; its loss is still mourned by many. The site is now a car park for visitors to the hill. Recently, aspects of traffic management (bollards and double yellow lines) have been imposed by the council, much to the chagrin of conservationists.

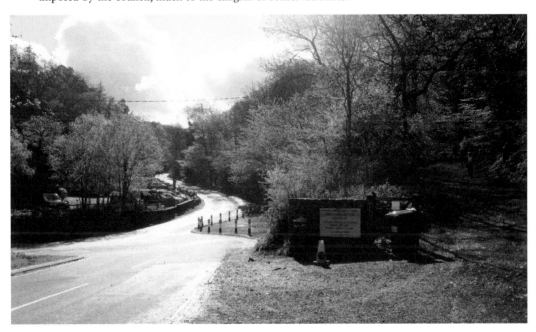

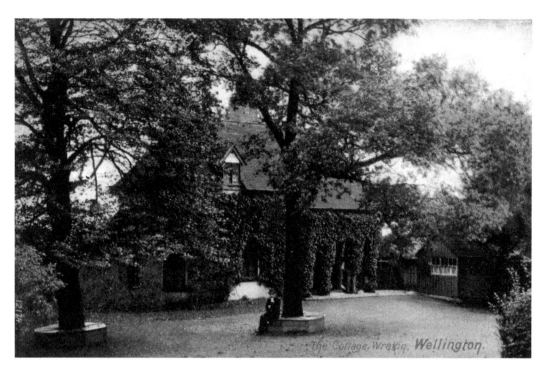

The Cottage, Wrekin, Wellington.

The Halfway House

A hundred years ago, locals thought nothing of walking to the top of The Wrekin and stopping for breakfast on the way down, such was the reputation of the Halfway House in providing wholesome meals at affordable prices ... served by waitresses in black uniforms and white frilly aprons! Those days are long gone, but present owner Tom Bolger still provides refreshments to those that need sustenance.

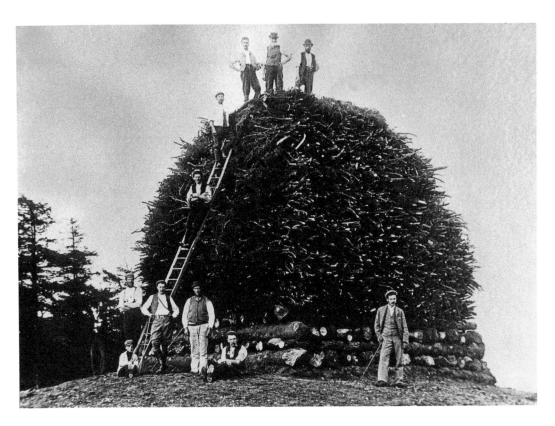

Beacons

For thousands of years, The Wrekin has had beacons burning on its summit in times of crisis or whenever a major event needs to be celebrated. The massive bonfire above was prepared to commemorate Queen Victoria's Diamond Jubilee in 1897, whereas that below welcomed in the New Year ... as 1999 turned into 2000.

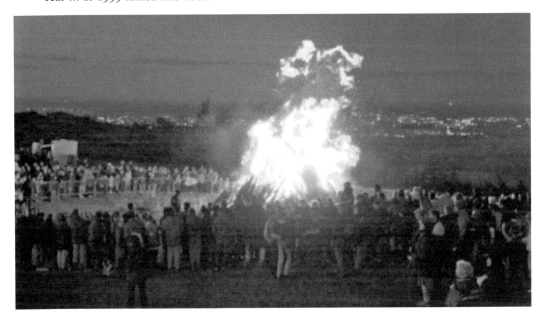

Acknowledgements

In addition to the author's extensive collection, grateful thanks are due to the following for their help in the gathering of old illustrations and information for this book:
N. Clarke, R. Corbett, D. Edwards, G. Evans, B. Felton, D. Frost, P. Frost, K. Lewis, P. Morris-Jones, D. Norcross, C. Powell, Shropshire Archives, *Shropshire Star*, *Telford Journal*, *Wellington Journal & Shrewsbury News*, Wellington Library, *Wellington News*.

Attempts have been made to trace copyright where appropriate and apologies are extended to anyone who may have inadvertently been omitted from these acknowledgements.

About the Author

Allan Frost through time ... in 2006 and 1956.

Allan Frost's great-great-great-great-great grandfather William Frost, a stonemason, first came to east Shropshire from the Cheshire/Staffordshire border around 1740 to help with mining operations; he decided to stay. Some 210 years later, the author was born in Wellington and specialises in the history of the town.

He has written over twenty-five books (novels, and histories of local businesses, specific towns and areas, including the world-famous Wrekin Hill), as well as numerous magazine and newspaper articles. Currently chairman of Wellington History Group and editor of its magazine *Wellingtonia*, Allan gives talks on a variety of subjects to schools, clubs and societies.